AUG - 2003

At the Edge of the Light

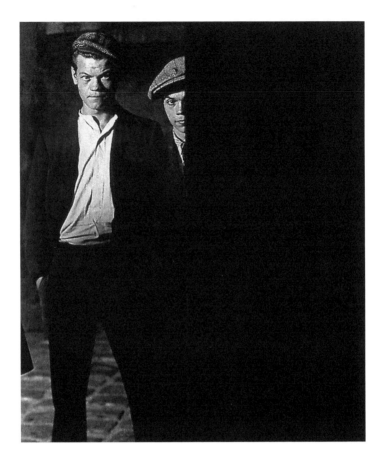

Brassaï
Deux gouapes de la bande du Grand Albert
1932

AT THE

Thoughts on Photography

EDGE

& Photographers,

OF THE

Talent & Genius

LIGHT

by DAVID TRAVIS

 DAVID R. GODINE
PUBLISHER · BOSTON

First published in 2003 by
David R. Godine, *Publisher*
Post Office Box 450
Jaffrey, New Hampshire 03452
www.godine.com

LIBRARY OF CONGRESS
CATALOGING-IN-PUBLICATION DATA
Travis, David, 1948–
At the edge of the light : thoughts on photography &
photographers, talent & genius / by David Travis.—1st ed.
 p. cm.
ISBN 1–56792–211–2 (alk. paper)
1. Photography—Philosophy. 2. Photographers—Attitudes.
3. Photographic criticism. I. Title.

TR185.T73 2003
770—dc21 2003009336

FIRST EDITION
Printed in Canada

770
T

Contents

For my Father

Introduction

GOOD LECTURES are not as engaging as good conversations. They are necessarily less spontaneous and allow only for the belated responses as suspended thoughts. But the best ones, like conversations, are ephemeral personal performances. Lectures by their nature are best suited to storytellers or to those with a Thespian flair, and in the scholastic world they have become a medium that is much abused, as I learned the hard way.

In 1985, I was asked to deliver a lecture on Eugène Atget to garnish the last major exhibition in a sequence of four that John Szarkowski and Maria Morris Hambourg had curated over the course of five years at the Museum of Modern Art. These breathtaking exhibitions were accompanied by the most beautifully printed and informative catalogues to date, as well as by symposia and lectures. Feeling that I was no expert on Atget, I initially tried to get out of the honor by replying that I could say nothing new about Atget. All I could do was to surround Atget's career with what had simultaneously occurred elsewhere in photography. Mr. Szarkowski said, "Great, we've heard too much about Atget already."

Despite the vast territory open to me, the lecture was a colossal failure. It was too complicated, too detailed, and – partaking of the greatest sin lecturers commit – it was far too long. My host, a fine raconteur, was polite enough to say in well-chosen words that the lecture was "very rich." On top of all that, I did not deliver it well. But as its dry monotones were like thousands of other art history lectures, I received no criticism of it at all. I was, in fact, invited to deliver it again at the Minneapolis Institute of Art, the next venue for the traveling exhibi-

tion. For that presentation, I cut out one third of the text, re-structured my reading script to be more narrative, and more importantly read it out loud five times into a tape recorder adjusting my diction and choice of words each time. My spoken voice happily emerged, as I painfully realized that a lecture is different than a glib dinner chat or a formal treatise.

The lectures in this collection have all been given since that disastrous Atget evening in New York. If my ideas in this book have any clarity, it is partly due to having prepared them as lectures. I learned that when the wording of any text starts to become convoluted and obtuse, the best remedy is to speak the words out loud either to yourself or someone else. Verbal coagula and vague thoughts show up with alarming frequency in this way. Free of such annoyances and finished as I thought these texts were as reading scripts, I discovered that they did not fare particularly well in silent reading. Humorous comments were not funny in print and courteous introductions were completely dated as were several of the anecdotes. Thus, some of the very elements that have helped to create a receptive mood within the auditorium had to be eliminated. Without their atmosphere and a certain nervous tension, these printed lectures are, of course, different than those delivered. But they are in other ways better, for what remains is still readable and durable in this residual format due to the skillful editorial work of my colleague Elizabeth Siegel.

I have chosen seven lectures for this volume because they reflect my own particular way of thinking about master photographers, all of whom have been much studied by others. These lectures also reflect my curiosity about the origin of artistic ideas. As scholars most often express their thoughts through their logical and linguistic abilities, I have included two

lectures about the relationship of the logical or the linguistic mind to photographic ideas. But, as artists mine different stores of intelligence than scholars, I have weighted the book toward the link between five photographic personalities and one of their characteristic photographs or a group of photographs. These lectures try to direct the reader's attention away from the notion that the photographs were images made primarily for our consumption or delectation. Rather, I want the reader to consider another aspect – that some images are expressions that found their form because of particular human conditions in the lives of the photographers. Even though we can never know an artist or anyone else thoroughly, we feel compelled to seek mutual points of understanding, especially in works of art, music, and literature. Because I believe that experience is the one absolute authority in the humanities, I have tried to give biography and psychology more credit than is common in the study of the work of these master photographers. As brilliant and profound as the study of theory has been in the last several decades in broadening the scope and depth of our comprehension of images, I find that it has left uncharted the huge continent of the lived experience as a source of visual ideas. It is in this direction that I began to turn in 1992 when the first version of "A Mind Among the Clouds" was written. I discovered that both famous and forgotten photographs revealed new meanings as I left the blazing campfire of theory and stumbled on fresh ideas out of its range in the place that Gary Snyder claims poems come to him – at the edge of the light.

At the Edge of the Light

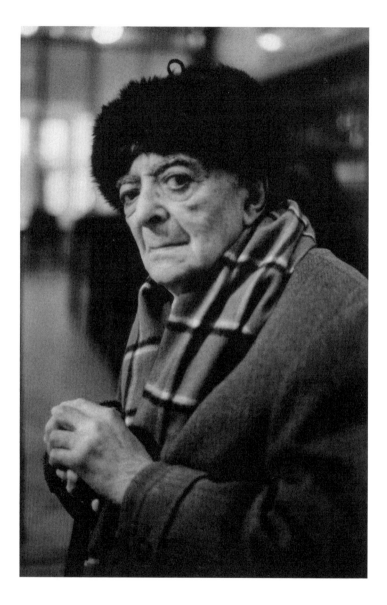

Alice Springs, *Portrait of Brassaï*
1982

Brassaï

ANECDOTES AND CONVERSATIONS

THOSE OF US who were regular visitors to 81, rue du Faubourg St.-Jacques knew to ring the bell marked Halász. After climbing the old spiral staircase or risking the tiny cage elevator, one always found a warm and welcoming man waiting for his visitors. He had been in the same apartment since 1934. It seemed small not just because he had enormous presence in it, but because for decades he had been overstuffing it with books, boxes of photographs, darkroom paraphernalia, small paintings and sculptures, old daguerreotypes, manuscripts and notebooks, and curiosities. He loved open, witty conversation and he seemed to have nothing to hide about his amazing life.

Once you got to know Gyula Halász, it was obvious that you were in the presence of an original. He was known by a single name, Brassaï, and looked like no one else. Even into his old age, one could see why Henry Miller called him "the eye of Paris." He had eyes to look and to be looked at. And he had eyebrows to match. By his appearance he was unique. By accent he was Hungarian, a trait that Enrico Fermi used to joke made these countrymen seem like extraterrestrial beings. Technically he came from the Transylvanian Alps, a region currently in Romania, but once ruled by Ottoman Turks, and well known for legends of vampires.

In the early 1970s, when I first met Brassaï, I knew little about him as a man. To those outside his circle of friends in Paris and professional acquaintances in publishing, he was a

3

photographic legend. The few other legends I had met by that time did not have the eyes he did; he was the only one who looked the part of the voracious observer he truly was. Later in the early 1980s when I visited him more regularly, it was to aid my research in preparing a retrospective of another Hungarian photographer, André Kertész. I was again seeking Brassaï's lively conversation and vivid memory.

I thought, at the time, I should *not* ask him about his friend André *directly*, just to be polite. Legends understandably have a need to be addressed on their own terms first. So I thought it would be clever to ask him what it was like to be a Hungarian photographer in Paris in the late 1920s and 1930s. I waited to hear his own particular version of the dream of arriving in Paris, finding an atelier, and hoping to become famous. I was all ears and ready to record his story of coming to photography via journalism after a career in painting failed to materialize. These would be the useful details of contrast I could use for the stage setting of my Kertész story.

Brassaï was helpful, of course. He always was. But he was forgivably hesitant to let his extraordinary life become a backdrop for someone else, even if it was an old Hungarian friend. Thus, I was unprepared for the playfulness of his answer, which was, I suppose, *his* way of being polite. Citing the Treaty of Versailles that had reapportioned Hungary after the First World War, Brassaï pointed out that his hometown of Brassó was now in Romania and thus forces beyond his control changed his nationality, which made him officially unqualified to answer. He paused and smiled. Thus, I had my first hint of an existence on the cusp. I began to see a mystery forming around him, and I was further enchanted. I should have been forewarned about his fluid identity from his certificate of the Chevalier de l'Ordre

des Arts et des Lettres awarded by the French Ministry of Culture. It hung prestigiously in a frame on the wall but scratched in awkward French lettering under his calligraphic name was the phrase that read: "otherwise known as Dracula."

Turning away from Kertész as the focus of our conversation, we talked about the twentieth century, the Middle Ages, Schiller and Goethe, and the writings of Nietzsche. We talked about Picasso and Henry Miller, both of whom had been subjects of books Brassaï had written; and about various French writers like Raymond Queneau or the poet Léon-Paul Fargue, with whom he used to wander the streets of Paris. And, of course, we talked a lot about photography from his point of view.

If there were just a half-dozen times and places in which photography was at its height as an art of invention and perception, one of these would have to be Paris between the two world wars – Brassaï's time, that is. In the later half of that period, the 1930s, few of those who became world-famous photographers had schooled themselves to do so. Of those with high talent only André Kertész, Germaine Krull, and Maurice Tabard actually planned to be professionals. And of these three, the one who would become the most renowned, Kertész, entered the profession as a self-taught amateur, never having had any proper training or apprenticeship.

Imagine a young person in that period – that is, a bright, talented, vivacious, and at least mildly egocentric person – who is open-minded and newly conscious about the world in the aftermath of the First World War. Such a person, looking around for a suitable vocation in the arts, would *not* find photography to be an obvious choice, for a couple of reasons. The first reason is that photography then had no prestige as a glorious profession of high respectability or cultural prominence like its

sister arts of painting, music, or literature. It had almost no known history. But prestige and history are not attractions to the adventurous youth seeking a new world. To anyone with daring, the profession of photography in the mid-1920s would have seemed too predictable as a calling. In addition, it was, for the most part, either a conservative or an anonymous affair. It was not a profession by which one could expect to have a fling with the unknown or become famous.

The second reason is that photography before the mid-1920s was not a pursuit that stirred the imagination, at least not as a profession. Commercial portrait photographers were generally flatterers in reactionary or vapidly stylish modes – or both. Architectural and product photographers were competent, reliable journeymen for hire. Press photographers, who would seem a more adventurous bunch, were almost always part of an anonymous mass of employees of news agencies or a publisher's staff and worked without individual credit. Company men, one might call them, as there were almost no women on the payroll. There was no known wildcard personality, even to serve as an exception to prove the rule; that is, no European proto-Weegee running loose on the scene. It was a predictable profession that ran the gamut of respectability.

On the other hand, there was a growing number of so-called artistic photographers, the majority of whom saw themselves as being above and apart from the profession. Although they did concern themselves with the imagination, they were generally rank amateurs or hobbyists who flocked to join clubs or entered work into self-aggrandizing contests and salons. Until the late 1920s, it would have probably been impossible for anyone in the general public to name a photographer of whom the rest of the national culture had heard. Only in the

Brassaï
Back cover,
Regards magazine,
No. 155,
December 31,
1936

regards

1fr.25

24 pages

Les
travaux
forcés
de
L'AMOUR

UNE GRANDE ENQUÊTE
DE
LYDIA
LAMBERT

United States had Edward Steichen begun to build his own celebrity, a perceptive marketing enhancement sanctified by Condé Nast and his editors and art directors.

In what was to become the golden age of photography in Paris, few of the great talents were French. Some of these visionaries were young Americans able to pursue their own dreams and careers thanks to the favorable exchange rate. After 1933, some of these photographers were German Jews fleeing Nazi fascism, and a few minor figures were Russians. A disproportionate number of them were Hungarian. This was a generation born between, say, 1890 and 1908 – that is, between the births of Man Ray and Henri Cartier-Bresson. Almost

directly in the middle of this generation stands the figure of Brassaï.

That few of the great photographers in Paris prepared themselves for the profession is not to say that they did not make any photographs; they did, and they photographed with passion, trying out experimental and personal visions of the world, usually with a small, handheld camera. The appearance of this inner urge to discover the medium is, not surprisingly, parallel with the urge to discover one's immediate world and one's identity in it.

For Brassaï that inner urge was not entirely photographic, as those who admire his pictures might like to believe. He was not a darkroom or camera buff, so to speak. As he reminisced in his 1976 book, *The Secret Paris of the 30s*:

For me too, or rather, for that other me of forty years ago, this infatuation for low places and shady young men was doubtless necessary. . . . For me fascination with the subject was always an indispensable stimulus.[1]

Maybe my fascination with the underworld in those days was inspired by the infatuation with outcasts I had derived from some of my favorite writers: Stendhal, [and] Mérimée, and above all Dostoevsky, [and] Nietzsche.[2]

Of these four, it is Nietzsche's name that is most often repeated and recorded by others as being on Brassaï's mind at the time.[3] He is also the author whose *Also sprach Zarathustra* "was pushed to new record sales as a 'must' for the soldier's knapsack" during the First World War, the war in which Brassaï had served in the Austro-Hungarian cavalry.[4] Nietzsche was the kind of thinker who could stoke Brassaï's mind to keep his inner urges burning. He was one of the two indispensable and enduring

heroes Brassaï came back to time and time again, at least in our conversations.

Nietzsche might help describe for us what a young, bright, talented, vivacious, and at least mildly egocentric person is. In writing of the imagination, Nietzsche crosses territory common to what I have feebly described as youth's inner urge. He writes:

Has anyone at the end of the nineteenth century a clear idea of what poets of strong ages have called inspiration?. . . – If one had the slightest residue of superstition left in one's system, one could hardly reject altogether the idea that one is merely incarnation, merely mouthpiece, merely a medium of overpowering forces. The concept of revelation – in the sense that suddenly, with indescribable certainty and subtlety, something becomes visible, audible. . . One hears, one does not seek; one accepts, one does not ask who gives; like lightning, a thought flashes up, with necessity, without hesitation regarding its form. . . .

Everything happens involuntarily in the highest degree but as in a gale of a feeling of freedom, of absoluteness, of power, of divinity. The involuntariness of image and metaphor is strangest of all; one no longer has any notion of what is an image or a metaphor. . . . It actually seems, to allude to something Zarathustra says, as if the things themselves approached and offered themselves as metaphors. . . . Here the words and wordshrines of all being are opened up before you; here all being wishes to become word, all becoming wishes to learn from you how to speak.[5]

That rhapsodic passage is edited from Nietzsche's last work, the autobiographical *Ecce Homo.* These words do not sound like those of an old philosopher, because Nietzsche wrote them when he was only forty-four. He would soon lose his mind and die ten years later. True, they are not the words of a twenty-something mind looking for a suitable profession in Paris.

Rather they are reflections on the experience accumulated in early adult life and of the mysterious origin of certain powerful ideas. But, for our study of Brassaï, they describe the excitement of an early career bursting with fresh discovery and in the throes of its first sustained period of confidence with what experience it had – something in perfect parallel to Brassaï's infatuation with photography.

When Brassaï's blazing encounter with the new medium and the Parisian underworld first took hold of him, he was about thirty-one years old, only a few years older than Nietzsche was when he began his hot streak. Incidentally, Kertész was thirty-one when he finally shook off dead-end Budapest and moved to Paris. Walker Evans was nearly the same age when starting his best work for the Farm Security Administration. Likewise, Robert Frank was just a year older when he started traveling across America on his historic Guggenheim Fellowship. These are the most famous photographic hot streaks in the medium's history, meaning simply that it is evidently a good age to catch fire with a camera in your hand. For Brassaï, at least, after this hot streak subsided, other urges within him were born or resurfaced, and models other than Neitzsche shared his attention.

All of this is admittedly abstract and academic. Before proceeding, one needs to acquaint oneself with Brassaï as a photographer and as a person. And as with many introductions, it is best to let our subject speak for himself:

I was born in Transylvania on the ninth hour of the ninth day of the ninth month in 1899. These numbers have pursued me all my life, and I live still at street number 81, [rue du Faubourg St.-Jacques]. The city of my birth, Brasso was a medieval town situated at the edge of Western civilization. There I was surrounded by pine forests, towers

*and walls, steep tiled roofs and the gothic church, nicknamed "the
Black One" [as the result of a historic fire]. . . . In my infancy I was
full of life and curious about everything.* [6]

*My father was a professor of French literature and had studied at
the Sorbonne. He adored Paris, and Sarah Bernhardt, as well as the
grisettes, the eighteenth century, and the French Encyclopedists and
Moral Philosophers.* [7]

*The year 1903 was my first trip to Paris. Residing with a French
family, I spent a year living the life of a little* Parisien. *We lived in the
rue Monge just behind the station for horse-drawn carriages whose
drivers and draft animals snoozed all day long. Later we lived in the
Latin Quarter near the Luxembourg Gardens.* [8]

These quotations are taken from a text Brassaï wrote when he
was fifty-three. His further descriptions of the visible pleasures
of *la belle époque* with its grand boulevards and public specta-
cles of dress and decorum, Buffalo Bill's Wild West Show, the
Eiffel Tower, puppet shows, and his favorite dessert, crème
caramel, seem especially vivid for a memory that was just past
the half-century mark. But that is characteristic of Brassaï's
modus operandi, which is to take something either from mem-
ory or from present experience and reconstitute it through his
artistry or for his immediate needs. This he does for his 1964
book, *Conversations avec Picasso* (*Picasso and Company*), when he
quotes the great painter from memory many years after his
visits and interviews.

After Brassaï's infant year in Paris, his family returned to
Transylvania where the young Halász grew up well cared for,
well educated, and loved by his parents. After the First World
War, when he was decommissioned from the cavalry, he imme-
diately set off for Budapest to attend the School for Fine Arts
and began to study painting. In December of 1920, he arrived

in Berlin. Berlin, if one did not make a stop in Vienna, was the preferred destination of escape from the repressive fascism of the Horty regime in Hungary. But beyond being an escape, Berlin was an attraction in its own right. Many aspiring artists, writers, and musicians sought their futures there in what was the nexus of Central European culture. Here Brassaï connected with an intense intellectual life and briefly crossed paths with László Moholy-Nagy, Wassily Kandinsky, and Oscar Kokoschka. He studied at the Berlin-Charlottenburg Academy of Fine Arts and discovered a new visual world, as well as Goethe's philosophy and theories of art and science. He was also a stringer for several Hungarian newspapers and sent back reports on cultural news as well as matters of which he could have had no profound understanding, such as German politics or the public lectures Einstein gave on his Theory of Relativity.

In 1924, his dream of returning to Paris came true. Supported by a meager and highly irregular income as a sports reporter and journalist for Hungarian and German newspapers, Brassaï painted almost nothing and sold less. If it was a penniless life, it was, at least, a romantic one, as one can sense from the many letters he wrote to his parents:

I could tell you about several all-night Montmartre outings to the "Mère Catherine" and other similar places. The most beautiful part of this is walking home through Paris at dawn, through the swarming market-hall, over one of the bridges on the Seine, through the Luxembourg Gardens in the full radiance of blooming flowers. And the conclusion: the third or fourth cup of coffee with the freshly arrived milk and the still warm, flaky croissants, with the papers hot off the press still smelling of ink. (February 12, 1925)[9]

Writing in 1978, Brassaï looked back on the ways he found

for staying alive in Paris and thus not having to return to Brassó. His memories were, as always, honest appraisals of his youthful activities:

I have no intention, then, of apologizing for the fact that I reported on the Olympic games even though I had no expertise (I did, however, know the jargon): that I was a caricaturist who followed the trail of sports champions and beauty queens and a ghostwriter who, at the request of German press sharks, unscrupulously manufactured fake interviews with world luminaries. We all supported ourselves by such methods, such fraudulent activities.[10]

By the early 1930s, things had not changed much for dreamers coming to Paris. Henry Miller, also penniless in Paris, remembered, "How many strange activities we engaged in then, grateful if we could make enough for a good meal."[11] Thus, one can guess the identity of the photographer Henry Miller wrote of in his 1934 *Tropic of Cancer*:

One day I fell in with a photographer; he was making a collection of the slimy joints of Paris for some degenerate in Munich. He wanted to know if I would pose for him with my pants down, and in other ways. . . . But since I was assured that the photographs were for a strictly private collection, and since it was destined for Munich, I gave my consent. When you're not in your home town you can permit yourself little liberties, particularly for such a worthy motive as earning your daily bread.[12]

Well, no more Paris of flaky croissants. But is this really our hero? Not quite. A letter Miller wrote to Brassaï's friend and assistant at the time helps to explain the characterizations, at least partly:

I am planning to make a niche for him in this present book. As it may

Brassaï
Illustration for
Scandale magazine,
No. 10, 1934

*be a very wild, a very lavish, a very extravagant portrait I should like
to know if he would prefer me to use another name than Brassaï in
referring to him? I want to include him for two reasons first in honest
tribute to his talent, second, because one of the principal themes of my
book is the "street," and in cher Halász I find a counterpart to myself,
I find a man whose curiosity is inexhaustible, a wanderer like myself
who seeks no goal except to search perpetually.*[13]

In another letter Miller's extravagance takes over his thoughts
as he gets carried away with describing Brassaï's penetrating
vision:

I have felt Halász' eye searing my eyeballs, peeling away the outer films

with his razorlike curiosity. . . . I have felt the penetration of his gaze like a powerful searchlight invading the secret recesses of the retina, pushing open the silent sliding doors of the inner eye which lead to the seat of the brain.[14]

Miller then goes on to portray the mystery of what he also sensed as the fluid and contradictory aspects of Brassaï's identity caused, I suppose, by his addictive curiosity, making his portrait of the photographer almost Faustian.

Halász, should he follow his intuitive bent, might carry us photographically to new light worlds I am sure of it! Because, even as we remarked last night, he is a man of ideas, one who is not flabbergasted by the rigmarole and the fanfare of technique. He is like a secretive insect who waits for the appearance of some unknown epidemic before commencing his ravages. He is stubborn and elusive. He does the banal thing in order to hide his monstrous eccentricities. He has the eye of a ghoul, the indifference of a leper, the calm of a Buddha. He is insatiable. He is a monster – the most amiable, the most courteous, the most raffiné – but a monster.[15]

Perhaps it is true; perhaps he really was otherwise known as Dracula. But whatever extravagances Miller's letters and novel contain, they are the only real portrait of Brassaï by a writer of any stature made at the time. When it came to the *Tropic of Cancer*, a book notorious for its extravagant passages, there is one section that is tamer, more considered and more respectful than Miller's letters, a section that one can be sure is a careful tribute to Brassaï, even though the photographer remains unnamed:

He was a good companion, the photographer. He knew the city inside out, the walls particularly; he talked to me about Goethe often, and

*the days of the Hohenstaufen, and the massacre of the Jews during the
reign of the Black Death. Interesting subjects, and always related in
some obscure way to the thing he was doing. . . . The sight of a horse,
split open like a saloon door, would inspire him to talk of Dante or
Leonardo da Vinci or Rembrandt; from the slaughterhouse at Villette
he would jump into a cab and rush me to the Trocadéro Museum, in
order to point out a skull or a mummy that had fascinated him. We
explored the 5th, the 13th, the 19th and the 20th arrondissements
thoroughly. . . . Many of these places were already familiar to me, but
all of them I now saw in a different light owing to the rare flavor of
his conversation.*[16]

By the time Henry Miller encountered Brassaï, the Transyl-
vanian Hungarian painter had already transformed himself into
a photographer. How did this man of daring deeds and daring
ideas come to take up a profession that only ten years earlier
was the sidetrack career of the anonymous or conservative?

The traditional explanation is that more and more often
Brassaï needed to illustrate his articles not with his own sketch-
es but with photographs, which he either collected or com-
missioned. Of course, it was not a big step to learn how to
make such photographs oneself. But it required a camera and
darkroom equipment, which was a big step for anyone with a
meager and highly irregular income, and certainly an obstacle
for a journalist who still had to rent his typewriter.

By 1929, when Brassaï first started to take photographs,
magazines were becoming visually sophisticated and a new kind
of photographer was just beginning to emerge. Press photog-
raphers became photojournalists and illustrated not only news
events but also human interest stories. Thus, anyone now con-
sidering photography as a profession could see a new poten-

Article on the
Eiffel Tower,
Vu magazine,
May 29, 1929

tial; a certain amount of fame and fortune might actually be possible.

In a May 29, 1929, story of the fortieth anniversary of the Eiffel Tower in *Vu* magazine, one sees a layout that contains what became one of Kertész's most famous photographs. And here one can see those unmistakable eyebrows posing in a photographer's prop. The team of Jean d'Erleich (otherwise known as Brassaï) and Kertész would collaborate on several other articles together. Human interest stories and, as one finds in other issues of *Vu*, serialized crime novels were now being illustrated photographically.

From another illustrations for *Vu*, one learns from the

Maurice Tabard
Illustration for
Vu magazine,
No. 60, 8 May,
1929

prominent credit that although Maurice Tabard took the photograph, it was staged and directed by none other than Jean d'Erleich. In another crime story illustration in the magazine *Scandale* one sees that Brassaï seems to have taken a further step toward being an *auteur*. Not only does he use his new name in the double credit with Jean Moral, but one can also see what appears to be a healthy set of eyebrows on the victim as well.

At the kiosks, newsstands, and bookstores, photographically illustrated magazines started to appear in greater numbers. Although many existed solely to satisfy the vicarious passions of their readers, they did try to dress up their contents with the fresh work of the new photographers. In his early career, Bras-

Brassaï

Photomontage,

Scandale magazine,

No. 4, November,

1933

Photo Monel - Brassaï

saï's main income as a photographer came from the publishers of *Scandale* and *Paris*. If one were to browse through their pages one would find the name of this soon-to-be-famous photographer under less than excellent photographs. Brassaï, however, was in his element and some of his better work first appears in these little publications.

Brassaï's coming to photography through illustrated magazines is only half the story. The other half of the tale, the compelling half, has to do with Brassaï's other infatuations. By taking his own photographs, he was not just trying to earn his irregular income more efficiently. What Brassaï discovered, probably from his friend Kertész one evening on a bridge over

the Seine, was that photographs could be taken at night. His imagination must have ignited as he thought of the nocturnal Paris that he knew so well and the thousands of possible photographs which he had already witnessed as an inquisitive wanderer into her secret places. Almost immediately, Brassaï was able to picture Paris at night using the camera to capture what was particularly beautiful and mysterious, as his early photographs show. But what was beautiful and technically challenging had been part of Kertész's infatuation with the camera for an even longer time. What set Brassaï apart from Kertész, and indeed from all of the photographers of Paris, is that he wanted to picture what was obscured from the everyday view, what was dangerous, and, most of all, what was forbidden.

One thing that made his work particularly dangerous is that the photographs he wanted to make could not then be taken surreptitiously, as candid snapshots taken on the run. The emulsions of his glass plates were too slow, his lens apertures too small, and the available lighting too dim. The famous set designer Alexandre Trauner, also a Hungarian resident in Paris at the time, often assisted his friend Brassaï by carrying around a huge roll of canvas that would be positioned outside of the picture, but which acted as a reflector for the overly harsh magnesium flash powder needed to expose the plate sufficiently.[17] Once one is conscious of it, one can see that the source of light in many of Brassaï's night photographs of people is not from the direction of the high street lamps or wall or ceiling fixtures.

These facts should not diminish one's opinion of any of his photographs. Brassaï did not use actors, but portrayed actual gang members, street roughs, pimps, and prostitutes as themselves. Zarathustra would be proud. Although posed, the characters were real and dangerous. If the client in *Introductions at*

Brassaï
Introductions
at Suzy's
c. 1932

Suzy's is Brassaï's bodyguard – a man named, of all things, Kiss – it is still not a false situation; just a factual untruth, perhaps. After all, it is not likely that the real clientele would let themselves be recorded so easily.

This inner urge to pursue dangerous subjects at this time in his early career put him in harm's way on more than a few occasions. Sometimes the danger came upon him a bit later, after editors had manipulated the photographs or recaptioned them. One of the many stories Brassaï told was this:

I was peacefully sleeping in my hotel room. Someone knocked on the door. Waking with a start I opened it. Before me stood a giant bran-

dishing a crime magazine. I recognized him: a marvelous mobster I had photographed in a bar in the Saint-Merri quarter. He thrust a picture in the magazine under my nose. The caption, which had been added by the editors, read something like: "This murderer who . . . that murder who". . . . "So I am a murderer, am I?" he said, pulling his cap down over his forehead and brandishing a switchblade. . . Luckily, I was able to wiggle out of it. Taking all my money, he left.[18]

Which proves conclusively, I think, that beyond being a great photographer, Brassaï was always first and foremost a brilliant conversationalist.

Whether one is considering the truthful fictions of Henry Miller's characterizations or the factual untruths of Brassaï's set-up poses of the Parisian underworld, one is not facing anything that contradicts the actual life experiences of either artist. Such mixtures are, of course, a necessary part of satisfying the demands of inspiration, especially if they are of the type Nietzsche described.

Posed photographs introduce an element of artificiality making them into apocryphal images or lending them an anecdotal flavor. One is now accustomed to that in advertising, but what one is not quite used to is having the characters play themselves in that condition Nietzsche described as things approaching and offering themselves as metaphors. Even if photographers understand this better than other artists, many viewers still like to believe that everything they see in a straight photograph is presented strictly on its own terms. Brassaï did not believe that such candidness could take place either technically or intellectually. He understood that reconstructed stories not only functioned as gossip masquerading as privileged information, but as a kind of revelatory fiction.

What holds for apocryphal images and anecdotes holds for conversations as well. An old Jean-Jacques Rousseau confessed, to no one's surprise: "I have often made up stories, but very rarely told lies."[19] How true is that, one may ask. Better to ask what would dinner conversations be without such liberties, or the café discussions on the Boulevard Montparnasse, or dates in cheap dance halls.

In the years I visited Brassaï before his death, he cautioned me about recording our conversations. If a tape recorder were running, he said one could forget about having a conversation at all: from a recording one obtained a voice on tape; from a conversation one engaged a mind at play. I think it was a polite way of saying that he thought it would be a waste of his time to talk but not to be able to converse. This was also his very polite way of indicating that I might have something to say as well.

Thus, I have no tapes to review from the many hours I spent in his apartment. This is probably to my benefit, as there is no surviving evidence of how ignorant I was in front of the master. Happily, for me, he never seemed bored or dutifully instructive, and I always found his mind at play. For instance, knowing that emulsions at the time were slow and lens apertures small, I once asked Brassaï how long his exposures were for his famous night photographs. Without hesitating, he said they were as long as it took to smoke a cigarette. "A cigarette?" I must have responded as my part of this brilliant one-sided conversation. He was already far ahead of me, but sympathetic to my own inability to comprehend the depths of my helplessness. Realizing that curators might take such an answer as an invitation to some esoteric research on the manufacture of French cigarettes in the 1930s, he generously offered to relieve me of what he knew would be a quandary when I found it. He explained that there were then

two kinds of cigarettes; one was the kind that he had smoked and that was still available; the other was a much more dense and tightly rolled kind. This second one was dubbed *le chomeur* because, as its name revealed, only an unemployed person would have time enough to finish it. I assumed that the brighter situations required one regular cigarette and it was only the really dark scenes that required *le chomeur*. I think now of the smile that came along with the explanation as one caused by a certain nostalgia for that glorious and septic period rather than any smug satisfaction in young curators.

Just when a curator has had some luck and thinks a subject is well researched, and thinks he knows and understands a genius like Brassaï, it is a good time for a humbling experience. After Brassaï had died, I visited his widow, Gilberte, many times to pursue the exhibition I had started when he was alive. I called it "The Complete Brassaï," as it was to take into account his various creative efforts in photography, drawing, sculpture, cinematography, stage design for ballets, and poetry.

Gilberte told me that Brassaï had died in Beaulieu-sur-Mer (July 7, 1984) on the Mediterranean coast just east of Nice. It was here that they had a summer house, and Gilberte mentioned, quite incidentally, that Brassaï had sought the location not only for the fine weather but because it was in this region that Nietzsche had written some of his last works.[20] Buying a summer house because of Nietzsche – it did not seem like a bizarre realtor's ploy as much as a clue I kept missing over and over because I was concentrating too much on Brassaï's career as a photographer and not on the whole, complex, and multifaceted Transylvanian person he was.

I asked Gilberte if she minded if I looked into some of Brassaï's books that still filled the apartment. The first book I took

down was *Also sprach Zarathustra*. It was a well-worn copy, printed in the old spiky fraktur German script. It was a small book, perhaps even the size once destined for a knapsack. I opened it to discover that Brassaï had underscored and annotated the text. How rare, I thought, to come across the traces of someone of Brassaï's genius in the act of thinking, or at least responding to another's thought. Of course, I scanned the text for underscored lines germane to my interests in Brassaï's photography, and immediately found this in Zarathustra's Prologue:

For that I must descend to the depths as you do in the evening when you go behind the sea and still bring light to the underworld, you over-rich star. Like you I must go under – go down, as it is said by man, to whom I want to descend.[21]

It turned out that Brassaï, like myself, could hardly read a book without a pencil in hand. Most of his books were underscored and annotated with marginal comments or short flyleaf essays or even an occasional sketch.

Soon Gilberte, Anne Tucker (the curator of photography from Houston), and I were driving out to a small suburb southeast of Paris to take a look at some of his other books, which had been given to Brassaï's nurse and her husband at the end of his life as a momento. When we arrived, we found shelf upon shelf of Brassaï's paperbound books, all in the water closet of the modest apartment. No amount of university training in libraries and study rooms prepares you for what you may actually face in the field. So, as the others occupied the conventional chairs, I was left with sitting on the only available seat in the water closet for the greater part of an hour thumbing through thousands of pages and making random notes mostly to my own memory.

I remember there was Louis de Broglie's famous book on quantum physics that Brassaï seemed to have read three different times judging from the three different colors of pencil underscoring. Here were some of his several copies of Schiller and Goethe, particularly *Faust*, in which I remember finding underscored lines marking out Mephistopheles' notion about the light and the dark side of mankind's sins. I reread *Faust* recently, and found what must have been the lines I read in the water closet. They are:

> *I never saw much value in these Greeks;*
> *They set the senses free in dazzling freaks;*
> *The sins they lure men to have light and spark,*
> *While ours are somber, always in the dark.*[22]

These lines fit Brassaï perfectly and what he had seen and experienced in Paris. It would not surprise me if I ever see that book again to find these other lines marked, words that Mephistopheles speaks to Faust:

> *And once you have it here, you hold the might*
> *To call heroic spirits from deep night,*
> *Hero or heroine; thus you are decreed*
> *The first achiever of this daring deed.*[23]

It would have been a good certificate for someone to have lettered out for Brassaï to hang under the one from the Ordre des Arts et des Lettres.

All Brassaï's books by Goethe or about Goethe were heavily underscored and annotated. Alexandre Trauner told me that when the two were in Cannes together Brassaï spent a great deal of time reading Goethe in preparation for a book he intended to write on him. If it was started, it was never fin-

ished. This may be one reason why Goethe always came up in his conversations: Brassaï may have been finishing the book in his mind and testing parts of it on each visitor.

The other reason that Goethe was never far from Brassaï's thoughts was that Goethe, probably more than Nietzsche, was his infallible inspiration and constant model. Goethe had a mind that was suited to dealing first with Nature and her physical realities and then with metaphoric meanings, a mind that Brassaï could study and revere. And he did, by quoting Goethe frequently. One of his favorite lines that visitors heard was: "I have gradually been elevated to the height of objects."[24]

Brassaï could not have hoped to duplicate Goethe's career as poet, playwright, natural philosopher, and statesman, nor his eighteenth-century lifestyle in the Weimar court. Rather Brassaï cultivated Goethe's curiosity and his imaginative and serene results. For Brassaï, Goethe was the perfect inquisitor both of the arts and the sciences, perhaps the last figure large enough both to write great poetry and to conduct scientific investigations on the theory and physics of color. Goethe was almost a secret source for Brassaï, as the great Romantic was not in intellectual fashion in the arts at the time. One needs to remember that in Brassaï's heyday it was not German Romantic literature but rather Dada-inspired Surrealism that was taking Paris by storm. As Miller and Trauner or any one of us who knew Brassaï intellectually can attest, it was Goethe to whom Brassaï returned over and over again, and it was Goethe's example that encouraged Brassaï to range from investigating the Parisian underworld to reading books on quantum physics.

After the suburban trip, Gilberte allowed me to rummage through box after box of books in Brassaï's old sculpture atelier. There were hundreds more books and I felt as if the sub-

ject of my exhibition, "The Complete Brassaï," was getting too big to explain to anyone, even with Goethe as the model. I was allowed to take some of the books back to the museum for study and it was there that my last, so to speak, "conversations" with Brassaï were held. I was handicapped by not being able to say anything directly to him, and he by not being able to respond in any other way than by his annotations. Sometimes it was hard to complete his thoughts, but he often helped by writing "*merci*" or "*merde*" next to a passage.

If I wanted to know what Brassaï may have had in mind from any of these scattered annotations, I started what I still call a "conversation." It could not, however, begin with one of my questions. Rather it had to begin with one of his answers. It was like a game.

For instance, on the half-title page to a book analyzing Hermann Lotze's metaphysics, Brassaï wrote:

We run around the present like a dog around its strolling master. Sometimes it's ahead and sometimes it's behind, only sniffing its master's steps. It is never really with him, except on the rare occasion when it takes the piece of sugar he offers.

If I guessed that this described the moment that a photographic exposure freezes time, it seemed a satisfactory conjecture, satisfactory until I remembered that Brassaï had no interest in representing the world in artificial split-second moments. The conversation then began in earnest, for there was a conflict. I knew for a fact that Brassaï did not perfect techniques or develop an aesthetic in any but a few of his earliest trials as a novice photographer for stop-action pictures. What later became known through Henri Cartier-Bresson's photography as "the decisive moment" was another path entirely. Brassaï liked

his subjects to be down to earth, stable, immobile, but with the kind of movement that sculptural objects have. When Brassaï says one meets the present only rarely, he means only rarely, and not with every click of the shutter. So whatever my conjecture was, it had to be a little more sophisticated than describing the photograph as a mindless slice of time. I thought harder, wishing he could respond. Then I realized from Brassaï's other marginal notes in books by Henri Bergson that the photographer appreciated the philosopher's idea that reality is not understandable as singular and discrete expressions or essences – snapshots, so to speak; rather, it is an inseparable continuum whose abiding character is flow and duration.

If we had been in a real conversation, and I asked further about the dog he observed on the Lotze flyleaf, I am sure he would mention the dog running circles near the beginning of the first part of *Faust*, which, of course, was Mephistopheles disguised as a poodle. But to hear any more of what he might say about it, I would have needed to have had the book in hand, which I knew was probably still on a shelf in a water closet in Ivry. So I was forced to bring up something else.

In our so-called "conversations" Brassaï was always true to life as well as philosophical, which kept him from making simple-minded claims. For him the camera was not a tool that automatically separated reality from illusion, but quite the opposite: it often exchanged one for the other. Nor did he glorify the camera as some ultimate mechanism of perception, or some metaphysical extension of sight. All of that for him was connected to the human eye and the mind behind it. This much one has already heard from Henry Miller, and this much I knew from our actual conversations. I saw it again in his books. This time it was in Henri Poincaré's *Science and Hypothe-*

sis where Brassaï had underscored a statement from the great mathematician: ". . . it is always with our senses that we serve our instruments."

With this line our conversation had a new set of bearings, for in the same book, Brassaï had underscored lines that indicate that whatever is arrested for inspection in some ways alters or even contradicts what is trying to be understood. Here one can imagine any number of experiences he had in the brothels or on the streets with Big Albert's gang. In fact, Brassaï every so often took advantage of chance occurrences on his own negatives to make new pictures altogether. If Poincaré, at the turn of the century, was anticipating the mysteries of quantum physics or Heisenberg's Uncertainty Principle, perhaps one can claim that Brassaï was anticipating deconstructionism. Maybe. But one would have to check further into Goethe to see where else this speculation could lead.

As I go on searching for his other thoughts and answers, I sense that something essential is lacking, and I know what it is. Brassaï's humor is not nearly as abundant in his annotations to himself as it was in his conversation. And here I am helpless and realize what has been lost even with the discovery of these stimulating and secret thoughts.

If one compares Brassaï to others in the great talent pool of photographers that made Paris between the world wars one of the golden periods of the medium, sometimes this unique photographer seems remarkably similar to his peers. At other times, it is obvious that he is more solidly grounded than those who are happy to experiment with the peculiar bird's-eye and worm's-eye views the hand camera easily provided. And, of course, most of the time he was not just the best but the only one of his kind.

If one looks at the dates of his photographs, one can see how Brassaï's life and career were changing. His sensationally successful book, *Paris de nuit* (*Paris by Night*) was published in 1933 and made him famous. He continued deeper into the underworld for a while, hoping to publish a book called *Paris secret* (*Secret Paris*), but only the unauthorized *Voluptes de Paris* was printed in 1934. With fame Brassaï received plenty of commissions photographing writers or artists in their homes and studios, especially Picasso and his sculpture for the official Surrealist magazine *Minotaure*. André Breton even asked him to join the Surrealist group but despite their many affinities, Brassaï had other alliances with his own heroes.

With Goethe in mind, it is much easier to see the parallels between the inquisitive natures of Faust and Brassaï. It helps to explain the fluid identity that one first encountered simply as Dracula. But Brassaï is not like the famous Transylvanian parasite as he takes in the world around him; he is, like Faust, seeking the higher meaning of things in hopes that he can raise himself up to them.

Like part two of *Faust*, Brassaï finds other worlds to explore, worlds that are not entirely earthbound. While linked to a Realist outlook, these worlds were, nevertheless, becoming more and more intellectual and literary for Brassaï, and less and less photographic. Even so, it is probably enough just to consider Brassaï as a photographer alone, as there is no one else who did anything like he did. But the more I read his books, and the more I read of the letters to his parents, I see that there is yet a more complete and complex Brassaï to discover.

There is a particularly revealing letter that he wrote to his parents on August 2, 1939, nearly on the eve of the Second World War, that gives a feeling for the honest way he could look

at his own success and what he thought he could yet accomplish as his hot streak in photography was ending. It reads:

I am still steadfastly hoping for a miracle, though catastrophe hangs over our heads and we must obviously be prepared for the worst. A good opportunity to update you on my situation, while it is still possible. Success has never been able to fool me, and I have never become a prisoner of my own fame. I've always had to measure whatever I accomplished against what I wanted to, and had to, accomplish. A couple of years ago, as I was approaching forty, all my dissatisfied demons awoke at once. They swept me into a crisis I had not faced since my Berlin years. It was obvious that, come what may, I had to free myself from photography. I had always considered photography to be a mere springboard to my real self but, lo and behold, the springboard would not let me go. Sometimes I was close to despair. What was a mystery at the age of twenty and an unrealizable hope at thirty, all of a sudden appeared as a very close, palpable, constructive reality – but at what cost! I have been fighting valiantly for three years. I have spread my wings! The clear view of objects has opened my eyes, and today I can see into the heart of matters. How can I catch royal game with this dragnet that is photography?

I had lived with three languages so long that I finally had perfect command of none. I had to grab the bull, the French language, by the horns. With the same commitment and persistence that allowed me to master the techniques of photography, I threw myself into the French language. Descartes, Pascal, La Rochefoucauld were my masters. Now I am well armed, my ideas no longer walk around slipshod: I am sure of myself. I have been writing French for the last three years. My ideas have poured into new territories and discovered surprising connections never before suspected and seen. Everything I have done so far takes on new worth in light of what I am currently striving to accomplish.

BRASSAÏ

Now you know with what self-confidence I look into the future. If fate were only gracious enough. . . .[25]

"I can see into the heart of matters." What more could a man of insatiable curiosity desire. Is this not the goal Faust selfishly wanted for himself? Like Goethe, but unlike Faust, what Brassaï saw in the heart of matters was not kept for himself. It was given back to us in his photographs, his writing, and, for a few of us lucky ones, in the rare flavor of his conversation.

André Kertész
After the Soirée
1927

André Kertész

A CLOSE EXAMINATION of this unpretentious snapshot
of a Parisian party reveals a few famous faces. Among the not-
quite-so-famous faces, experts in Hungarian Constructivist
painting will recognize Ida Thal, the woman in the middle
wearing a white dress. The Italian Futurist specialists will find
Enrico Prampolini to be the short man in the center. Students
of Modernist German painting will identify Willi Baumeister
as the big gentleman behind them, and the architectural buffs
will find Adolf Loos, the third one in from the right. There is
at least one famous, household-name artist among them, an
artist that everyone would know: the second man in from the
right is Piet Mondrian.

Missing from the picture are Hans Arp, Tristan Tzara, the
French poet Paul Dermée, and the host of the evening, Jan Sli-
vinsky, a Polish lieder singer and proprietor of the gallery Au
Sacré du Printemps.[1] Somehow these four figures have already
slipped away. The group had assembled for the first of what
would be eleven evenings that presented *œuvres d'esprit nouveau*.[2]
The *soirée* doubled as the *vernissage* for an exhibition of paint-
ings by Thal and photographs by André Kertész, all arranged
by Dermée and Michel Seuphor the Belgian poet, editor, and
art theorist, who is the serious young man in the snapshot to
the left of Mondrian.[3]

One of the liveliest members of this congenial group
appears to be Mondrian. If the great abstractionist seems a bit

André Kertész, *Seuphor on the Pont des Arts*, 1926

out of character for us, it is because we may know him only from photographs in which he often appears as rectilinear as one of his canvases. He had a livelier side and, as his friends knew, a passion for dancing whatever was the current rage. In this party picture, we find him in his out-on-the-town mood, ready for an evening on his toes.

Mondrian was a friend of Seuphor, who later wrote a definitive biography of the great Dutch artist. It was Seuphor who brought André Kertész to the painter's studio just the year before, and who asked him to take photographs there, especially one of the vase of tulips that stood on a small table. At the time of this party picture, Seuphor and Kertész had seen a lot of each other. Seuphor himself had been the subject of some of Kertész's early Paris portraits taken in the Hôtel des Terrasses where the photographer made portraits of other writers and artists who rented modest rooms there.[4]

In his native Antwerp, Seuphor had co-edited an arts journal[5] and through his travels around Europe had become a young man full of ideas and fluent in advanced art theory. In the summer of 1926, the sophisticated Seuphor met the modest Ker-

André Kertész, *Chairs, the Medici Fountain*, 1926

tész, who had for the previous eight months quietly occupied himself in taking romantic photographs of Paris.

More than fifty years later, Seuphor remembered meeting him in these words:

During the summer months, you could see me, here and there in Paris, at the side of a puny little man with a frightened look, who held his camera in his hand or mounted it on a tripod. I piloted this poor devil from Budapest, who spoke not one word of French, through the Luxembourg Gardens to the Pont Marie, from Mondrian's studio to my hotel room, from the Pont des Arts to Montmartre. He wanted to photograph Paris, her squares and her parks. I instructed him to photograph the chairs, even just the shadows of the chairs, and he did. . . . He was

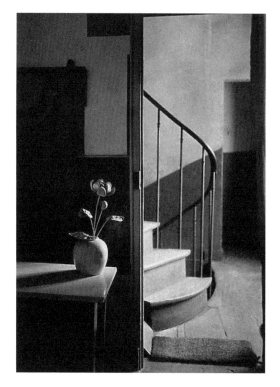

André Kertész
Chez Mondrian
1926

hard up, miserable even, and . . . photographed everything that I wanted and designated.[6]

Seuphor's memory seems to have soured between his excursions and his recollections. To understand this, we should remember that in their peripatetic tour none of the Kertész photographs seemed destined for greatness, especially to Seuphor, who must have viewed them as snapshots, as casual as a photograph Kertész had taken of him snoozing one sunny afternoon under his *canotier* on a bench of the Pont des Arts.

But after half a century, a few photographs that once seemed almost trifles became celebrated masterpieces or curious works

of art, and photographers gained respect and became serious. Kertész was hailed as a genius and Seuphor must have thought the case a bit overstated knowing the pedestrian origins of the famous works. Besides that, there must surely have developed a few personal differences. Nevertheless, Kertész must have had a stimulating time alongside Seuphor in 1926, disregarding as much as he absorbed while he maintained that lyricism could survive in a camera facing a world crazy with abstractions.

Piecing together the truth from what Kertész and Seuphor remembered is almost impossible now. Although the diagonal chair shadows in the Luxembourg Gardens made complete sense to someone like Seuphor who knew Mondrian's diamond canvases, which were then at their peak, the gaiety of genius in Kertész's innocent photograph comes not just from how the shape of its unusual shadows sit, but how they dance about on their humble gravel stage. In this photograph taken at the Medici Fountain, Kertész engages a piece of geometry with a bit of surrounding nature, while *Chez Mondrian*, taken at the same time, is an interior version of the same idea turned inside-out. A photograph simply of the shadows, although it might have been more abstract, would have been for the photographer a puny little visual decoration. Likewise, the tulip by itself would have been merely a miserable, lifeless document.

There seems to be no argument that it was Seuphor who brought Kertész to Mondrian's studio. After all it is Seuphor's *canotier* that we see hanging there on the peg.[7] Kertész's appointment book for 1926 lists four such visits, the first two on the 19th and 20th of August.[8] If one of those is precise for dating *Chez Mondrian*, it would explain the summer hat on the rack, as would the third appointment on the 2nd of September. If *Chez Mondrian* had been taken during the last listed appoint-

André Kertész
Lajos Tihanyi
1926

ment, on the 30th of November, we would expect to see a felt hat rather than one of straw. In bringing Kertész to Mondrian's studio, Seuphor may have wanted Kertész to photograph something special there: three stage sets that Mondrian had created for a play Seuphor had written earlier in the year. It shows in one of his photographs as the object against the wall on a little table in the famous studio. Kertész made photographs not just of the studio but of Mondrian and friends admiring another of Seuphor's privately published works.[9] For the aspiring young writer, all of this was just too much of an honor to leave unrecorded. Fortunately, for him, Kertész was there.

Before visiting Mondrian's studio, Kertész had absorbed a

fair amount of Modernist art through a circle of Hungarian and expatriate artists. We can see this in the portraits of his new friends in their studios. His appointment book shows a flurry of studio visits in January 1926: to Gunvor Berg, to Lajos Tihanyi, to Artigas, and to Wally Wieselthier.

If we add to this list the names of Gyula Zilzer and another Hungarian artist, József Czáky, whom Kertész met not too many months after his arrival in Paris in October 1925, we sense the beginning of his new approach to photography. But in Kertész's photographs in Mondrian's studio, he made a quantum leap. This does not have anything to do with what Seuphor wanted to get out of Kertész's work nor strictly with Kertész's new approach. It has to do with the site, with the special character of Mondrian's studio itself.

In order to reach Mondrian's studio at 26, rue du Départ, one had to walk immediately to the east of the huge Montparnasse station. In fact if one were to stand on the platforms there, it would have been right in front. This *quartier* was not the elegant place that peasant dreams made it out to be. Bertrand Poirot-Delpech sketched the contrast of its realities:

Here Breton girls tumbled out of trains from Quimper and were picked up by Faubourg Saint-Germain baronesses who turned them into maids, and by pimps from Pigalle who turned them into whores. Maids and whores alike had abortions at the back of courtyards filled with the fragrances of lilacs. . . . At dawn, the "Dame aux Camélias" would leave the Right Bank's cushioned bowers [for Montparnasse] to breakfast on the hot blood [of slaughtered] animals. Doctors said it was good for her consumption caused by high living. . . . There's nothing like living between the butchers for being oneself to the hilt and constructing the utopia of a work.[10]

41

Even if Mondrian's four-story building was not between butchers, visitors said the stairway leading up to the *troisième étage* was smelly. But the climb to the top and the foul odor were worth enduring, for among all the ateliers of Paris present and Paris past, Mondrian's was a special utopia. It was itself a work equal to any of his paintings. Mondrian felt that it was just as difficult to arrange and paint a room as to compose and execute a canvas, and for years he worked to perfect his studio. His friend Georges Vantongerloo had helped out by painting the large wall behind the easel in white with gray squares. With the rest of the room painted white, Mondrian positioned a few of his paintings and moved around squares and rectangles of red, blue, and yellow, attaching them to the walls. Although similar designs for interiors were part of De Stijl decoration, Mondrian did not consider that what he was doing was decoration as such, but the creation of a work in which he himself could work and be inspired. As he said:

With me there is no absolute opposition as with Léger, who discriminates between easel painting as condensed innerness and the superficially pleasing decorative wall. . . . my painting is an abstract surrogate of the whole. . . . Instead of being superficially decorative the entire wall gives the impression of the objective, universal spiritual condition. . . . [11]

His place was, as he once said to a visitor, a little sanctuary.[12]

Mondrian's studio proper was so overwhelmingly his that the only photographs in which Kertész was able to claim a little something of his own were of an odd corner detail of the skylight, which is strongly a Mondrian composition, and a still life of Mondrian's pipe.

Both compositions revealed Mondrian's excessive tidiness and meticulous adjustments to his working environment. Other

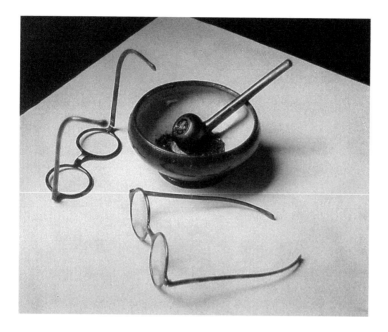

André Kertész, *Mondrian's Pipe*, 1926

visitors had noticed this as well. César Domela recounted that "if you lit a cigarette in his atelier and you put the box of matches down in another spot, Mondrian would get up to put it back in the original position. Otherwise the composition in the atelier wouldn't work any longer."[13] No wonder even good friends like Seuphor said they never stayed very long, even if the painter insisted.

In looking at a floor plan of Mondrian's studio and apartment it is difficult to imagine the location of the table with the tulips next to the door.[14] Seuphor's description of entering Mondrian's quarters is helpful:

In the center of the brown, painted door was Mondrian's visiting card. Opposite the door, a dark hole: the water closet. Next to the door, a

PAINTING
STUDIO

LIVING
AREA

ENTRANCE

TABLE

STAIRCASE

Floor plan of Mondrian's apartment

dirty window looked out on a sad courtyard with crumbling walls. This door opened into a small room, half bedroom and half kitchen. . . . But as a rule, the visitor saw nothing of all this; a skillful use of curtains formed a corridor, which led him toward the studio; this he entered after climbing five or six steps in the dark. Then everything changed. The room was quite large, very bright, with a very high ceiling.[15]

So the tulips in the vase stood at the entrance to Mondrian's living quarters and not in the studio proper. Again Seuphor's description of them is revealing:

Mondrian's entire love life was marked by . . . failures, affairs which were always cut short. . . . So strongly did he feel the lack of a woman in his daily life that he always kept a flower – an artificial flower sug-

ANDRÉ KERTÉSZ

gesting a feminine presence – in the round vase standing on the hall table. . . . This was so strange and unexpected, that in 1926 I had it photographed. Mondrian did not lack a certain attraction for women. But, despite his simplicity, they soon found in him something mysterious and impenetrable which turned them away. At times he had a priestly air, something that no woman likes.[16]

His priestly air and the making of his studio into a sanctuary were not affectations on the part of Mondrian, but rather a manifestation of his belief that high Modernist abstraction and geometric harmony were an "objective, universal spiritual condition," a kind of geometry sacred enough to rival the ancient Pythagoreans. In Mondrian's view, the divine could not be reached by painting representations of *things* but by painting representations of *relationships*. Thus, as Seuphor observed: "To live for him meant to measure the absolute."[17]

One might say that Mondrian became his studio and vice versa, even down to the squarish moustache that Kertész captured in one of his better portraits. Through Mondrian's studio Kertész gained an initiation into the speculative realm of creating and saw it realized there with religious intensity. Harmony, whether it stems from Pythagoras or Mondrian, is, after all, essentially a mystic's idea of the sanctity of certain proportions. But as Kertész demonstrates in *Chez Mondrian*, a photographer does not have to give up an intercourse with irregularities to partake of its results. Working within the work that Mondrian had created of his studio and living quarters gave Kertész a glimpse of the serenity of the absolute that helped to discipline his lyrical eye. Even the portraits he exhibited several months later at Slivinsky's gallery were now expressions of a simple kind of organic geometry.

At this point it may be instructive to say something not

André Kertész, *Gallery Group*, 1927

about the images but about the actual prints of Kertész's *Chez Mondrian*. From two installation photographs Kertész made of his exhibition, one can ascertain that he mounted his photographs on a paper board and pinned them to the wall.

They seem to be about eight by six inches, indicating that they were specially made enlargements. Up to that point, Kertész had only made contact prints on post card stock. But these "post cards," so to speak, were not intended for stamps and salutations. They were beautifully finished works, many inscribed in the lower left-hand margin with a minuscule pencil signature and delicately titled "Paris" in the lower right. When Kertész wanted to illustrate what he was up to in Paris to his mother, his brother Jenö in Argentina, or to Elizabeth Saly, the woman he left behind in Budapest, he enclosed these postcard prints in

his letters. The verso of a *Chez Mondrian* post card carried this message to his brother: "*L'Esprit nouveau* is coming out in mid-January. A new artistic magazine. This picture will be published there." Kertész was not referring to the journal edited by Corbusier and Ozenfant, which ceased publication in 1925, but to its one-issue successor, *Documents internationaux de l'esprit nouveau*, which was edited by Dermée and Seuphor.[18] As it turned out, it was delayed several months, and although several Kertész photographs appeared, *Chez Mondrian* was not among them.

Chez Mondrian did, however, begin a life of its own, for this was the photograph that Kertész probably printed more often than any of his other works in the period, meaning ten or fewer times. Although it seems not to have been reproduced until 1943, Kertész included it in many of his early exhibitions: it was at Slivinsky's, then two years later in 1928 at the "Salon d'Escalier" – the legendary exhibition in which Atget was first shown, at a similar exhibition in Brussels that same year, in a 1930 exhibition in Buenos Aires, and at the Julien Levy Gallery in New York in 1932.

It is strange to think that such a famous photograph remained unpublished for so long. (The same was true of *Satyric Dancer*, also a 1926 photograph, which was printed in only three examples.) *Chez Mondrian* only really started to become famous in the early 1960s with exhibitions at the Museum of Modern Art and the Bibliothèque Nationale, and with a 1963 article Brassaï wrote for *Camera* on his friend's photographs. But new readers and admirers loved it either as a reproduction or as what the auction houses now term a "later print." It no longer had the modesty of a postcard photograph printed by a puny little man with a frightened look. It had become the work of a master.[19]

If we want to recover any of the shredded truth about the circumstances of this great photograph, we would do well to avoid describing Kertész's encounters with Seuphor and Mondrian simply as "influences." That overused term masks what happened in Kertész's imagination and dulls the genius that was his alone. It implies that the Neo-Plastic structural overlay was everything that was worth anything in the photograph. Kertész, like any artist, dreamed his own dreams and discarded as much as he absorbed. Nevertheless, visiting Mondrian was of enormous help, and not only to a modest photographer like Kertész. In 1930, Alexander Calder also left Mondrian's studio dreaming his own dreams, dreams of floating colored shapes, dreams of what became his mobiles. As he recollected:

> [The studio] was a very exciting room. Light came in from the left and from the right, and on the solid wall between the windows there were experimental stunts, with colored rectangles of cardboard tacked on. Even the Victrola, which had been some muddy color, was painted red. I suggested to Mondrian that perhaps it would be fun to make these rectangles oscillate. And he, with a very serious countenance said: "No, it is not necessary, my painting is already very fast." This visit gave me a shock. . . . This one visit gave me a shock that started things.[20]

Mondrian's "objective, universal spiritual condition" set both Calder's and Kertész's imaginations ablaze with reverence *and* innovation, which makes one wonder if the work in which to work was Mondrian's own main stimulus. Probably by this time it was. Earlier in 1922, before the studio was perfected, an unexpected stimulus was apparent. In that year, a woman visitor complained about the pinned-up photographs of naked dancing ladies all around the bedroom/kitchen area. "I do that in order to remain a little objective," Mondrian bashfully replied.[21]

André Kertész, *Self-Portrait at a Table*, 1927

A good bachelor's escape, I suppose, but who is to say they were not a secret source for the imagination of a Neo-Plastic dancer of the fox trot and Charleston. In his bachelor apartment Kertész mounted a photograph of the Eiffel Tower and draped his table with a cloth embroidered by his mother.

What a good son. Or at least that is what he would have his mother believe in a 1927 self-portrait that he dutifully sent to her. Whether we can identify them or not, each artist required his own peculiar stimuli, and even an elevated imagination like Mondrian's needed its own private inconsistencies to keep it from sublimating beyond recovery.

As persuasive and powerful as Mondrian's studio was to a photographer just finding his way around Paris, Kertész's genius was not incarcerated there as a prisoner of "influence." It was, if anything, liberated. Shy and unlearned in French as he

was then, it was easy for him to appreciate what the environment meant. Later on, as his ego and vision grew, it would have been a little harder.

Paris in the summer of 1926 was a particularly great time to be alive, even if one were a puny little immigrant from Budapest. Artistically, it was just the time to be out on the town. And as Kertész felt the beat of one current artistic rage, his genius seems to have danced through the myriad of directives and sophistications laid in its way, danced with the spunk of a man ready to spend a whole lifetime on his toes.

ANDRÉ KERTÉSZ

Curiosity and Conjecture

Mathematics, Photography, and the Imagination

I

FROM ITS INCEPTION, photography has had an identity crisis. The chemical registration of light as an optical phenomenon was invented simultaneously by an artist and a scientist. Louis-Jacques Mandé Daguerre was a Parisian impresario and painter, and William Henry Fox Talbot was an English mathematician and scientist. Although we are not certain if the idea of photography occurred to Daguerre in a scientific way, we do know that it occurred to Talbot in an artistic way. It also occurred to him in a romantic way while honeymooning in the Italian Alps. As Talbot himself reported, the idea of photography presented itself as a way to get around his inability to sketch a decent souvenir of the scenery at Lake Como, even with the assistance of a camera lucida drawing aid.

Although mathematics is much older, it too has occupied territories that were neither completely within the arts or sciences. For the Pythagoreans, mathematics had the mystical properties of a religion. Now most people think of mathematics as a part of science, which like photography is not quite subsumed by it. From what I have experienced firsthand from the study of number theory and from what I have learned by reading the history of mathematics, I have come to realize that mathematicians, at least those who call themselves pure math-

Athanasius Kircher, *Large Portable Camera Obscura*, 1646

ematicians, are as much like artists as scientists. I came to this
notion in a roundabout way.

I used to think that curators were not offered sabbaticals.
At the Art Institute of Chicago I found out, however, that
eight weeks are available every five years. Thus, if we curators
need more than half a semester to recharge our broader imag-
inations we have to take what I call a *peripatetic* sabbatical while
performing our other duties. During a *peripatetic* sabbatical,
one's off-duty intellectual pursuits are carried around in a half-
suspended state as one tries to look as if one is still moderately
connected with whatever else is going on. I took my sabbati-
cal walking around the ground floor of mathematics. I took it
in mathematics because I needed an escape from art criticism
and history as well as a way to look at the creative process with
new eyes. I got as far away from my professional discipline as
I thought I possibly could by revisiting a subject I had aban-
doned as an undergraduate. Perhaps I hoped that this retreat
would provide some inspirational Dada-like irrelevancy to

enhance my professional expertise in a field dominated not by facts but by personalities.

I suppose if a scientist were to spend a year or so seriously studying critical theory in twentieth-century art as an escape, he or she might find their rational way of thinking to be a handicap in attempting to make sense of a field that cheers as Oscar Wilde says: "I am but too conscious of the fact that we are born in an age when only the dull are treated seriously, and I live in terror of not being misunderstood."[1]

Suffice it to say that personalities in the arts may be possessed by a different temperament than those in the sciences. If the irrational sensibilities of a Max Ernst rule the age under study, the scientist might easily feel as if being misunderstood was really the whole idea. But I suppose I could be wrong and what the poet Rimbaud termed "a senseless voyage of discovery" would be all the more exhilarating for scientists as an escape from their goal-oriented habits.

As I found out, it can work the other way around. In respect to the fine arts, a proper understanding of number theory requires that every line and symbol *not be misunderstood*, and that whatever is produced be so clearly true and evident that it can be demonstrated to the rest of the world in the form of a written proof. This is a kind of rigorous thinking that has prevented artists and curators from investigating mathematics, especially in the last century. The experience of another field and the character of its thought can, however, be a revelation if one perseveres. It is a matter of not being intimidated at the onset and of finding a suitable level of entry.

As I started to read mathematics again, I encountered a difficulty that I had often heard people express about photography. It was difficult to sense where the mathematician had had his or

her insight, that is, where the creative element first occurred. Likewise in photography, viewers often ask where the artist entered into the creation of the picture. This is because photography is often seen as the process – as an optical, mechanical, and chemical affair from start to finish. In mathematics, insights were also covered over by definitions, axioms, and rules of inference. On this level, mathematics seemed to be a monumental edifice of notions and notations. It had the same objective finish as an architectural photograph: perfect but impersonal.

This correspondence between two artificially perfect worlds goes back centuries to the astronomer Johannes Kepler. By employing an optical instrument that was a kind of camera obscura, Kepler made extremely accurate drawings, boasting even that he made them, as he said, *not as an artist but as a mathematician* (*non tanquam Pictor sed tanquam Mathematicus*). He was, of course, tracing by hand the optical projection of a lens, but to his mind he was establishing a one-to-one correspondence with the scene outside, which is closer to how a mathematician would describe it.[2]

After some effort, I was able to "see" the beauty of certain mathematical ideas. To "see" a mathematical proof requires that one experience a kind of momentary and intellectual "aha." I recognized this as the kind of intuitive experience a photographer has in knowing exactly where to be and when to snap the shutter.

Let me demonstrate a little "aha" for you. In our family, my sons and I like to enter an NCAA basketball playoff pool. There are 64 teams in a single elimination tournament that captivates the American sports mind for the month of March. One year after the forms were filled out, one son asked how many games there were. My first mental response was to reformalize the

question: in the first round there are half as many as the number of teams, in the second round there are half as many as the remainder, and so on until there are but two contenders. Thus, if you start with an even number of teams, call it x, you can write the mathematical formula:

$$x/2 + x/2/2 + x/2/2/2 + x/2/2/2/2 +$$
$$x/2/2/2/2/2 + x/2/2/2/2/2/2$$

and so on until the denominator and the numerator are equal, meaning they equate to one, that is the championship game. But the addition of this string of divisions can be a bit laborious if there are hundreds of teams, and no one really experiences any significant "aha" in doing it that way. The "aha" for me came later when I read about another way to do it.[3] In a single elimination tournament, every game has a different loser; a team can only lose once, and only one team does not lose. Therefore, the number of games is equal to the number of losses. (Bye games do not count as a loss.) Thus, the number of games is equal to the number of teams that lose, which is to one less than the number of teams: 63 for the NCAA championship tournament, or generally: x-1. That was a more satisfying "aha," and it was clear enough for my eight-year-old son to understand immediately.

Understanding puzzles like this one has given me a glimpse of what mathematicians call beauty. If the resulting "aha" is a strong one, the sense of beauty comes because the shock of understanding somehow gains an intensity of feeling, the feeling of pleasure and satisfaction, that is.

What I have described crudely as the "inner aha," shared both by photographers and mathematicians, has been described with more authority.

Here is G. H. Hardy, one of the great English mathematicians of his day, writing in 1940, at the end of his career: "The mathematician's patterns like the painter's or the poet's must be beautiful; the ideas, like the colours or the words, must fit together in a harmonious way. Beauty is the first test: there is no permanent place in the world for ugly mathematics. . . ."[4]

Knowing this might be a bit misleading, Hardy goes on to qualify his remarks: "The best mathematics is serious as well as beautiful. . . . The 'seriousness' of a mathematical theorem lies, not in its practical consequences, which are usually negligible, but in the significance of the mathematical ideas which it connects. We may say, roughly, that a mathematical idea is 'significant' if it can be connected, in a natural and illuminating way, with a large complex of other mathematical ideas."[5]

Since such expressions of aesthetics being the central motivation in scientific invention and discovery are not at all uncommon, I asked myself, if leading scientists and mathematicians can make intelligent comments on what art claims as its very subject, why have not curators made intelligent comments about mathematics or science? Perhaps it is because mathematics and science are exacting disciplines that tolerate little unfounded speculation. This makes them treacherous for outsiders. But for those of us in the arts and humanities to be intimidated by rigorous thought would be to fail to extend a hand to meet the one already offered by Hardy.

From those of us who have ventured in on our own, I have a tip for those who may follow: begin on the ground floor, if you want to actually experience that "inner aha." It cannot be had by reading a secondhand explanation. The beauty of mathematics must be in its doing for there are no objects to hang on the wall in gilded frames.

II

If most of us are now to do some mathematics together, it will have to be basic, it will have to come from the ground floor. In my first example, I know we are on the ground floor because one morning at breakfast my eight-year-old son said, "Dad, you know if you add an even number to an even number you get an even number." I responded by asking if his teacher had told him this. He said, "No, it just came to me." Of course, he had just been adding up even numbers and noticed the pattern. But a mathematician would not stop at a pattern; a mathematician would want a proof. First a mathematician would express the statement symbolically:

$$2m + 2n = 2(m + n)$$

that is to say two different even integers added together would equal an integer always divisible by two, which is to say even.

I am proud to say that my son went on to say that adding an odd number to an odd number, the result is an even number. Or as mathematicians would write:

$$(2m+1) + (2n+1) = 2(m + n) + 2$$

and we can see when factored this way that it is even because each component of the expression on the right is even (and we have just shown that even numbers added to even numbers result in an even number). And with a little coaching my son discovered that adding an even number to an odd number results in an odd number. Or as mathematicians would write:

$$2m + (2n+1) = 2(m + n) + 1$$

and that expression is odd because adding one to an even number will always result in an odd number.

Charles Sheeler
The Stove
1917

One can go on to show that even times even is even; that even times odd is even; that odd times odd is odd.

Since the idea had occurred to an eight-year-old, I feel it is a basic idea. The question that then occurred to me was how to characterize this idea. The question occurred to me because in the field of art history we try somehow to characterize the product in our best descriptions. In mathematics, however, such characterization is not so common. Thinking of my young son helped me to characterize these formulas. As you may know, a child of eight likes to have a very stable, predictable world. He wants nothing out of place. It has to be regular, and everything is better if it is composed of simple parts.

I then thought, what photographer's work exemplifies that for me?

Although there were several possibilities, the photographs of Charles Sheeler were paramount. As one looks at his work, one discovers a world that is stable and predictable, with nothing that seems out of place. It is regular and seems as if it were constructed exclusively from simple parts. Sheeler, both in his photography and his painting, made a career using this idea. If things seemed jumbled, Sheeler's geometric sense organized them to a point that lines and volumes seemed almost plottable.

So, after entering the ground floor of mathematics in this way, I went on, through its Euclidean hallways. Although it seemed schoolboy stuff, trying to find a characterization for formulas and related ideas proved to be enlightening. The Pythagorean Theorem was particularly instructive, for it suggested a different kind of photographer.

Euclid gives an ingenious proof of this theorem through geometry. He did it through geometry because the Greeks did not have the simple algebraic notion that even grade-schoolers learn today. They could not write out:

$$a^2 + b^2 = c^2$$

or any of its various other forms. They had to prove the theorem with just lines and measure. What the Pythagorean Theorem means in lines and measure is that in a right triangle the area of a square in which the measure of the side is *a* added to the area of a square in which the measure of the side is *b* equals the area of a square in which the measure of the side is the diagonal line completing the triangle, or side *c*. The genius of the proof Euclid shows in the *Elements* is in a line he drew. The line is from the vertex of the right angle to a point

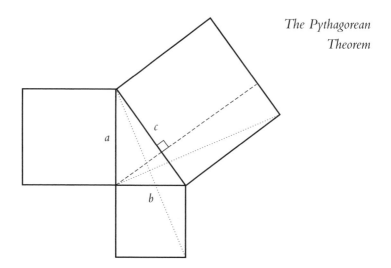

perpendicular to the hypotenuse and extended to the opposite side of the square of measure c. This line divides the square of measure c into two rectangles. Using a fact that Euclid had proved about the area of any triangle being equal to one half the area of any rectangle of equal height and of the same base, he showed that the area of square a was equal to one of the rectangles of c and the area of square b was equal to the other rectangle of c.

It needs a diagram to make it clear. But what I want to suggest is that the drawing of that special line was a stroke of genius. And to whomever the position of that line occurred must have experienced a significant "aha." That line proved the theorem, a theorem that took only lines and measures and achieved a formula that indicated another dimension, or if we art historians might venture a characterization, almost another world, another existence.

I thought to myself: What photographer's work characterizes that notion for me?

CURIOSITY AND CONJECTURE

Henri Cartier-Bresson, *Hyères, France*, 1932

What photographer had a basic sense of geometry and to it introduced another element that created another dimension, another world, and another existence? For me, it was Henri Cartier-Bresson. Certainly in his early career this is obvious. For example, in his 1932 photograph of the bicycle rider in Hyères, France, the scene of the street, the steps, and the railing is an interesting photograph geometrically. But the addition of the bicycle rider caught in motion, caught in the close fit of the geometry, makes it a piece of genius. It adds another dimension. This insertion of this new element in Cartier-Bresson's photographs is analogous to the line that Euclid drew. And it works over and over again. His early photographs were like a set geometric trap and the photographic picture, for him, was not there until he added another element, the dimension of incidence.

As often happens, art historians or critics say that what

Cartier-Bresson added was a piece that made the photograph surrealistic. By describing it that way, the discussion and the discovery stop. The discussion is diverted to how the term surrealism is being defined. By comparing it to Euclid, however, it becomes interesting again because it comes closer to the creative moment itself, to the "inner aha."

Let's examine another simple mathematical proof, one of Euclid's most beautiful: the infinitude of primes, as the textbooks call it. Just to review, you need to remember what prime numbers are. They are integers – whole numbers – that have no factors: 5, 17, 41, 53, for example. That is, no factors other than themselves and 1. The question for Euclid was "How many primes are there?" The question occurred to him, I suppose, because prime numbers could be seen as the building materials of other numbers, the composite numbers. For instance, the number 99 is composed of the factors 9 and 11, or if further factored to primes to 3, 3, and 11. It is a unique composition; 99 has no other combination of prime factors. The Fundamental Theorem of Arithmetic states that either an integer is prime or it is composed of a unique combination of primes as factors. If numbers are either prime or composite, one might ask if there is a limit to the basic stock of primes from which all the composite numbers can be composed. Euclid said there was not, that the number of primes was infinite. How did he prove it?

Euclid proved it by contradiction. (Or as a logician would say, by the law of the excluded middle.) Euclid made an assumption and found a logical contradiction. First he assumed that the number of primes was finite. That meant that in a well-ordered set of numbers one of the primes would have to be the largest. He called that prime P and then concocted a number by multiplying together all of the primes up to and includ-

ing the number P. We can conceive of that number but, of course, it is much too large to write down. We can see that this gigantic number, call it Q, is not a prime because it is composed of all the primes. By definition it is evenly divisible by each prime. If we now add one to this gigantic composite number what do we have? It might be a prime or it might be a composite number:

$$Q + 1 = (2 \times 3 \times 5 \times 7 \times 11 \times 13 \times 17 \times 19 \ldots \times P) + 1$$

The question, however, for Euclid was just a bit more subtle. He asked not if "$Q + 1$" was a prime, he asked only if there were any primes larger than P. If P was the largest prime, and all the primes were contained in the number Q, then it meant that one of the primes must divide into both Q and "$Q + 1$." But reasoning will show that it is impossible for one number to divide both a given composite and the integer one larger. It cannot do that because if it divides the lesser number, it must leave a remainder of 1 when it divides the larger. Thus, Euclid had found a contradiction proving the contrary of his original assumption. Thus, given that with any prime there is always a larger one, he concluded that the number of primes is infinite.

Again I thought of what this proof could characterize. A mathematician would not ask such a question of their proof. The characterization I made was this: no matter how far out you go there is always something strange, unique, something prime. Something that you cannot reduce to other known factors, something you cannot control or produce by formula.

I asked myself, "What photographer might be said to be interested in that notion?"

For me, it was Garry Winogrand. No matter where he went, something happened in front of him, something unique,

Garry Winogrand, *Cape Kennedy, Florida, 1969*

something that had no explanation, no description by other factors, something that could only be experienced by looking at it. As he discovered these situational primes, he photographed them. Mostly, he took his photographs where any of us might: in the zoo, at parties, or just out on the streets. Peculiar situations were abundant, even perhaps infinite. There were primes everywhere: in Texas, California, Chicago, Cape Kennedy, and, of course, in his native New York City.

Another mathematical proof one encounters on the ground floor of mathematics pertains to the measure of $\sqrt{2}$. If we have a number system based on integers and extend it to fractions formed by the division of two integers, we might ask, "Do we have all that we need for simple geometry, for just lines and measure?" You might have guessed already that the answer is bound to be "No." This distressed the Pythagoreans, for they had thought there was some mystical significance in the har-

mony of the relation of whole numbers. What they came to realize was that the diagonal of a square is not measurable in these rational numbers. That is, if the side of the square is one unit of measure, then the diagonal, $\sqrt{2}$, is not expressible as a division of any two integers. The proof is again by contradiction.

Assume that there are two integers that do divide one into the other to produce $\sqrt{2}$. We assume that the two integers have no factor in common, that is, as a fraction they are fully reduced. (Of course, if the two integers are not reduced, they will still produce the same rational number, and if they can produce a rational number for $\sqrt{2}$, then we can still express them in their reduced form if they have common factors. So we start with the reduced fraction, since all other multiples of it can easily be produced later.) If there were two such integers, then we could write this formula:

$$a/b = \sqrt{2}$$

and that can otherwise be expressed as:

$$a^2/b^2 = 2 \quad or \quad a^2 = 2b^2$$

This means that a^2 is even, and if a^2 is even then – from what we learned about even numbers multiplied by even numbers – we know that a is even. So, if a is an even number it can be expressed as the product of another integer and 2. Thus, we can write:

$$a = 2c$$

If we substitute this back into our second reconfiguration of the formula we have:

$$(2c)^2 = 2b^2 \quad or \quad 4c^2 = 2b^2 \quad or \quad 2c^2 = b^2$$

and that means that b^2 is an even integer, and that further

means that *b* is an even integer. If *a* and *b* are both even integers this means that they both have a factor of two in common, which is contrary to our original assumption that they shared no factor. Thus, $\sqrt{2}$ is not a rational number, it is irrational.

This fact might be illustrated by the rational number line. No matter how densely you fill in the line with finer and finer rational numbers, with finer and finer fractions between the integer *1* and the integer *2*, there will be a gap at $\sqrt{2}$. This sim-

ply means that one system cannot perfectly measure the other, except by approximations, or the best available guess. It seems a bit of a paradox that one can conceive of the diagonal of the square and even draw one, but its exact measure in relation to the unit sides can only be an approximation. One can see why the Pythagoreans revered the 3-4-5 right triangle. Such right triangles were of dimensions that could be expressed fully in rational numbers, and thus measure the hypotenuse exactly. Although the 3-4-5 right triangle does not have this incommensurable problem, as it turns out such right triangles measured with integer units are exceptional.

I thought to myself, "What photographer's work characterized this condition?"

For me, it was Robert Cumming. In his work, one can see the playfulness with which he addresses the idea of the incommensurable and the need for a best available guess. In one example, we see a pair of photographs; the one on the left shows the formula:

$$0 + 0 = 0$$

But the photograph on the right gives away the trick, for in it we see that the zeros might not be read as zeros but what they actually are: doughnuts. Thus the silly truth of the matter is seen in the second photograph: one doughnut plus one doughnut equals two doughnuts ($0 + 0 = 00$).

Over and over in his work, Cumming sets up two explanations that cannot coexist; that is, one cannot be the measure of the other. In the work titled *Two Explanations for a Small Split Pond*, Cumming proposes either the two halves of the improbable desert pond were formed by a bucket of dirt spilling across an existing pond, splitting it in half; or that the split pond

came about because a single bucket was cut in half, and the water poured to form the two ponds.

As I said, the peripatetic sabbatical I took was only on the ground floor of mathematics. Even so, I gained a glimpse of what was upstairs. Upstairs you might find the name Gregor Cantor on a door. A visit to his offices is always stimulating, if a bit confusing for those of us making our way through the Euclidean hallways.

One of Cantor's best-known ideas has to do with infinite sets. Cantor says that the character of an infinite set is that a subset of it is also infinite and is of the same size. He gives an example involving even numbers. The curiosity for most of us who encounter this strange proof for the first time is that it indirectly asks whether there are the same or half as many even numbers as natural numbers. From our finite, practical point of view, it would seem that for every even number we can name, there exist twice as many natural numbers. But Cantor says if you try to list them, you may convince yourself otherwise. List the even numbers and count them using the natural numbers:

$$1, \; 2, \; 3, \; 4, \; 5, \; 6, \; 7, \; 8, \; \ldots, \; N, \; \ldots, \; \infty$$
$$2, \; 4, \; 6, \; 8, \; 10, \; 12, \; 14, 16, \; \ldots, \; 2N, \ldots, \; \infty$$

Cantor says that these two lists end up as being the same size infinity, an infinite set that he called "aleph-null." Although he went on to describe larger infinite sets, let us deal with this relatively simple one. If the set of even numbers is an infinite set, but still a subset of the natural numbers, and if, as Cantor says, these two sets form the same size of infinite set, then I suppose we might find an analogy to this situation in the work of photographers using view cameras.

Minor White, From *Sequence 15*, 1959

If a photographer is focusing on the ground glass of a view camera, and we assume that the number of points of light is infinite within the frame and that they are gathered from an infinite number of points of light from the world outside, we have a Cantor-like situation. If, however, as Cantor says, these two sets are equal, suppose we consider the world from which the "photographic" points of light are gathered to be the subset. What characterization would that suggest? To me, it suggests that the ground glass image – that is what will become the photographic picture – is a world unto itself. The photographic picture then becomes the primary image by which the rest of the world is to be measured or compared or approached. This invaginated reasoning suggests that life imitates photog-

raphy, as the picture editors and photographers in fashion magazines would have us believe.

What photographer came to my mind? Although Richard Avedon or Irving Penn would work, it was Minor White who had a mystical side not unlike a devoted Pythagorean.

When White photographed ice or peeling paint, galaxies appeared, or a cosmology when he captured the encrustation on a wall. His photographs were worlds that seemed complete in and of themselves. Even though they, like most camera images, had taken some visual fact from the outside, they did not refer to it again, but rather related it to some human experience, to some unanswerable question.

I would like to illustrate one last mathematical idea with work by Charles Sheeler, our first example. In 1917, Sheeler made a photograph (illustrated above) of a wood-burning stove in a country house he shared with Morton Schamberg. Around 1932, the same stove reappears, this time as a larger crayon drawing he is making of it while seated at an easel in a self-portrait. Later, in 1943, Sheeler used the self-portrait and incorporated it, along with the drawing of the photograph on the easel, and put it in the corner of a painting, which he titled *The Artist Looks at Nature*.

Although Sheeler took a geometric shape that was stable, predictable, regular, and composed of simple parts, he made it a more complicated image by reintroducing it into a later drawing, a photograph, and finally a painting. Although something seems to remain the same, the farther we go in this process the more intriguing the result, the more it plays to our imagination, and the more it resembles the ideas of Benoit Mandelbrot and the iterative process of mathematical recursion.

There are, of course, many other mathematical theorems

Charles Sheeler
Self-Portrait at
Easel
1932

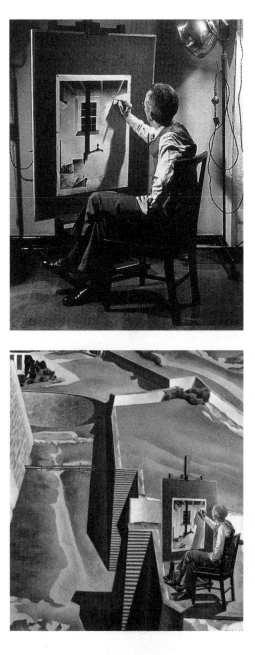

Charles Sheeler
The Artist Looks
at Nature
1943

that could be treated in this way, and I am sure that mathematicians would only find extending this practice to be at first a harmless amusement of art historians and then an annoyance. It is, however, an instructive technique. One might even say it is enlightening to find new metaphors, an age-old technique of furthering learning and creating a new resonance within the larger world of creative thought.

III

Up to this point I have been making correspondences between the character of mathematical theorems and those of photographs. If it wasn't a convincing argument that mathematics and photography have something in common, perhaps it was a curious one. But a curious connection is all I seek. For it is curiosity that will keep us going, and take us beyond superficial resemblance toward something fundamental.

I rely on curiosity at this point because I want to indicate, even characterize, creative ideas. Curiosity is such a fundamental ingredient for mathematicians that they use it to link logic to number and make it the essence of their art. When it is dressed in its formal attire, they call it conjecture. One might say that the goal of mathematics is finding the right conjecture, which parallels what Wallace Stevens said is the moral goal of poetry: finding the right sensation.

At this point, a conjecture occurs to me about mathematics and photography. The conjecture is that there is no difference in the way a creative idea comes to a mathematician and the way one comes to a photographer. I am cautious, however, when speaking of ideas as if they were deemed the essential products of art, for there is a piece of a conversation that someone preserved between the poet Stéphane Mallarmé and the painter

Edgar Degas, that warns us about going too far. It goes like this:

DEGAS: *Voilà, I've got this great idea for a poem!*

MALLARMÉ: *Alas, mon ami, poems are made out of words, not ideas.*[6]

That notion has been defended by other poets, like William Carlos Williams, who claimed there should be "no ideas but in things."[7] If ideas do not make good poems, perhaps ideas do not make good photographs either. Or maybe they do. Perhaps they do if we redefine the aesthetic experience as the shock of understanding that nearly gains the intensity of pleasure. This is part of an active debate that is still going on in contemporary art and criticism, a battle to understand the relation of conjecture and sensation. Nevertheless, my conjecture still holds: there is no difference in the way a creative idea comes to a mathematician and the way one comes to a photographer.

My only assurance to those of you who see the sense of William Carlos Williams's conviction that we are not going too far astray into a thicket of ideas is that I shall attempt to deal with very simple correspondences. But even that direction is fraught with snares, as that wonderful observation by Einstein cautions: "Everything should be as simple as it is, but not simpler."[8]

The question these days is: Are there any simple answers left, even simple, provisional ones? Have not photography, electronic imaging, and everything else become their own complexities through technology and critical evaluation? Sometimes it just takes someone who is not quite a tourist to enter with an informed but different point of view. A new point of view sometimes does clear away old complications, momentarily, or at least long enough for our curiosity to get a glimpse of a vista with its complications still on the horizon.

I remember when I started to read mathematics again, I was particularly drawn to number theory, an area of the discipline that lures amateurs with the simplicity with which the most difficult problems can be stated. It has also attracted brilliant minds, and as I studied what they had put down in proofs, I would occasionally have trouble. I was no wizard, and I had no instructor. There were times when I would spend a couple of days getting from one line of a proof to the next. This was more frequent than I would like to admit, and because of that I noticed a pattern. I noticed that when I got unstuck it was often in the morning after a good night's sleep. Sometimes, however, the enlightenment came as I was walking up a certain parking ramp on my way to the museum. It was a curious pattern, but as I later found out, it was not so uncommon.

Listen to Jules Henri Poincaré, the great French mathematician who introduced dynamical systems which created a foundation for today's chaos theory: "To create consists precisely in not making useless combinations. . . . Invention is discernment of choice."[9]

Now even though all true photographers will recognize this "discernment of choice" as fundamental to their art, I want to illustrate something else that Poincaré links to this idea:

Among chosen combinations the most fertile will often be those formed of elements . . . which are far apart. . . . For fifteen days I strove to prove that there could not be any functions like those I have since called Fuchsian functions. I was then very ignorant; every day I seated myself at my work table, stayed an hour or two, tried a great number of combinations and reached no results. One evening, contrary to my custom, I drank black coffee and could not sleep. Ideas rose in crowds; I felt them collide until pairs interlocked, so to speak, making a stable combination. By the next morning I had established the existence of a

CURIOSITY AND CONJECTURE

class of Fuchsian functions . . . I had only to write out the results, which took but a few hours. [10]

After this, Poincaré relates how in stepping onto a bus or walking along a bluff another related idea came to him with the same characteristic brevity, suddenness, and certainty.

To me, all of this is very much like a photographer who looks out on a scene. At one moment it is what anyone else might notice, but almost imperceptibly through some reframing of it – some moment of it, some combination of it with something else, some perception of it – it becomes a picture.

As I said, this sudden illumination is curious but common. At least one psychologist has written that "To invent, one must think on the side."[11] But what I discovered, not unsurprisingly, is that the mind must not be empty. The subconscious, or whatever we might call it, has to be occupied with the problem. From my own experience, I realized that it was necessary to "charge" myself for days, weeks, or even months, with as much as I could hold of the problem, and, if I was still blocked, seek a release by doing something else. The best something else I found was sleep. Next to that, for some inexplicable reason, it was walking up the ramp at the Monroe Street underground parking garage. Sleep seemed a bit more reliable, however since it was effortless and because the parking ramp was rather short for as slow a thinker as I am. Further research led me to the very pleasant discovery that the great René Descartes – who was without the benefits of a good isolated parking ramp – was in the habit of staying in bed musing until 11:00 A.M., alone with his thoughts.

The next question is: How does this illumination operate? Among the scattered books I consulted was *The Psychology of Invention in the Mathematical Field*. To an art curator, it looked

like an imposing title, but it turned out to be rather friendly. It was written by Jacques-Salomon Hadamard, a colleague of Poincaré, who knew Einstein and was familiar with the psychological thought of his day.

What is encouraging in the Hadamard book is that he constantly mentioned how a sense of beauty guides thoughts and decisions when there is nothing rational on which to base them. He not only reflects his own observations but also cites Poincaré's notion that the work of the subconscious is aesthetically driven. And not to take his only examples from mathematicians, he also quotes the turn-of-the-century French poet and philosopher, Paul Valéry, who writes:

The privileged unconscious phenomena, those susceptible of becoming conscious, are those which . . . affect most profoundly our emotional sensibility. It may be surprising to see emotional sensibility invoked à propos of mathematical demonstrations which, it would seem, can interest only the intellect. This would be to forget the feeling of mathematical beauty, of the harmony of numbers and forms, of geometric elegance. This is a true aesthetic feeling that all real mathematicians know, and surely it belongs to emotional sensibility.[12]

Now finally, here is someone of authority to say mathematicians make use of beauty and emotions, even though their final results seem to mask them very, very well. And I think this is where the simple, fundamental correspondence between the mathematician and the photographer will be found. If we define the imagination operationally, rather than glorifying it as a special inherent gift or a mystical source of thought, we will "see" all kinds of hidden correspondences. Listen to Valéry again: "It takes two to invent anything. The one makes up combinations; the other one chooses. . . . What we call genius is much less the work

of the first one than the readiness of the second one to grasp the value of what has been laid before him and to choose it."[13]

Here again the photographer can identify with the circumstances. Choosing is the final, essential act of creativity. If, as Poincaré suggests, the subconscious brings up ideas in pairs or in crowds, it is up to us to choose what makes sense to us. If, as he suggests, this bringing into consciousness is directed by an aesthetic force, the best one can do is to not undo it, but take it as it is, and verify its usefulness, seriousness, or stimulating curiosity. By this act, by reading, by conversation, by observation, by listening to music, by meticulous experiment, by habitually daydreaming, by taking peripatetic sabbaticals or just quiet walks, one can recharge the subconscious with focused ideas, which lets the subconscious go back to work in suggesting other things.

What I call imagination is simply that active and corresponding link between intuition and rationality.

I know the mind goes back and forth between them, not from being a curator caught between critics and practitioners, or even one caught between art and science – I know it from my experience with reading proofs in number theory. It was made abundantly clear to me from my failures. The more difficult the proof, the more concentration I needed in order to keep my mind operating rationally. At the slightest interruption, the delicate thread of a thought is broken. It takes an effort to knot the thread and get going again. I am convinced that the mind cannot confine itself in either intuition or rationality indefinitely. Even great artists and scientists cannot ensconce themselves exclusively in one part or the other. To get anywhere, their minds must alternate between the two, like a sailboat tacking between port and starboard when sailing to weather.

For many people the model of the perfectly rational mind is that of a mathematician's. But I discovered how some of the greatest ones credit intuitive, irrational thinking as the genesis of their creative work. The alternation is real for artists, as well. As Valéry says, genius can be a matter of just choosing. This is something of which photographers have been champions for decades on end, often to the ridicule of those who tend to have rather romantic ideas about what the imagination is.

The problem, of course, is getting the ideas to come. Most people are lazy and don't charge their minds sufficiently. Knowing what the favorable conditions for creative thought are, of course, a big help. The contemporary poet Gary Snyder has described in a poem how a poem comes to him.

> *It comes blundering over the*
> *Boulders at night, it stays*
> *Frightened outside the*
> *Range of my campfire*
> *I go to meet it at the*
> *Edge of the light.*[14]

When ideas do come, they are, at least in my case, rather tiny. They are not thunderbolts, but glimmers. After they are received, enhanced, and stabilized they eventually need to be reintroduced back into the subconscious. This I do by playing with them, connecting them, and measuring them against my other thoughts whether relevant or not. This kind of "charging" helps them enter the subconscious. The whole process is rather like a recursive mathematical function, like the Sheeler painting of an artist looking at a landscape. Great photographers, mathematicians, and poets know what to choose as this alternation progresses and accelerates because in the results that are produced

and fed back in, they see patterns, correspondences, and metaphors with other things they know or have done. If they hit it right, when they extract something, something new is created. If not perhaps they have just not made the right conjecture. They are blocked and frustrated, stuck like a photographer waiting for picture at the wrong place and an ill-chosen time.

It is when something happens in our minds that we notice, that we experience, the "inner aha." When something happens in the mind of photographers, often without their claiming it as a conscious thought, they take a picture. If some reflex led them to it, they often call it "the decisive moment." But that is a hardened English translation of a more fluid phrase that Cartier-Bresson created, one that in its original French is less decisive, less exact, less certain, and more conjectural. His original phrase was *image à la sauvette*, an image taken on the run, taken as something ephemeral, something Gary Snyder would say is out at the edge of the light. *Image à la sauvette* describes the photographic genius for reflex and reflection. And it seems to me that it is a good description for that moment when the unpredictable subconscious makes its first tentative suggestions to daydreamer and cogitator alike. That moment can be as unreliable as memory, and when we are stuck it is probably best to take a break, to do something entirely different, seek a release in something beautifully irrelevant, like staring at a good Max Ernst painting or embarking on a senseless voyage of discovery well outside the boundaries of one's profession.

Joel Sternfeld

McLean, Virginia, December 1978

(original in color)

The Plot Thickens Everything

RETURNING HOME to Rome from a vacation in the Italian Alps, a traveler gathered his friends together in a local trattoria. He wanted to tell them of his recent culinary adventures. So he ordered a round of drinks and began the tale of a small village he had discovered. It had fabulous food and was so incredibly tidy that none of the men there had beards. They were also a self-reliant people and refused to employ anyone from the outside for their daily needs.

"It was a joy," the traveler said, "to find a place that did not care to have anyone else to worry about their well being."

"Ah, but they must have a very good barber," his bearded friend replied, "because not everyone likes to shave."

"You're right. I was told that there was an excellent barber living there," the traveler answered, "who shaves every man who does not shave himself. They've got it all worked out. The whole town is helpful and charming, especially in the restaurants."

This was more to the point, as the real story he wanted to tell was about a delicious dinner of rabbit and mushroom risotto. So he ordered another round of drinks and began in earnest, telling of the slow, tortuous drive up the mountainside in chilly evening air, of the glow of the inn, of the rotund owner, and above all, of the aroma of the meal in preparation. His mathematician friend, the one with the beard, suddenly asked, "Hey, who shaved the barber?" A third friend, a photographer, somewhat annoyed by the setback, volunteered that the barber must

have shaved himself. With a sigh, the traveler went on to the details of the rustic table setting. But the mathematician cut in again, "Noooo. The barber shaved those who did not shave themselves. As the barber, he could shave himself, if he did not shave himself." A typical mathematician, the other two thought. The photographer, who was a practical observer of the world, then offered that one of the villagers shaved the barber as a favor. Relieved once again, the traveler launched into a description of how the feast began, how with cocktails in hand the host had invited the dinner party into the kitchen to inspect the glorious, simmering risotto and chat with the chef.

"Noooo," the mathematician broke in again. "Our friend distinctly said that the barber shaved those who did not shave themselves."

"OK," the photographer answered marshalling his smattering of mathematical reasoning, "They were *all* barbers!"

There was a brief moment of silence, and then another kind of sigh, as this answer satisfied neither the mathematician nor the traveler, who responded,

"It was not a village of barbers."

As this was an impasse that required more stimulation, the traveler stood for another round. This was not the way the risotto lover had envisioned the unfolding of his narrative, and it seemed that the divine meal was fated to remain forever on the storyteller's stove. Besides that, it was getting late. The profit-minded manager of the trattoria had also noticed the hour. He sent his most ingratiating waitress over to see if she could find a way to get rid of them before the evening crowd arrived. As the manager looked on, the waitress leaned over the table into the knotted conversation, listened for a moment, and said something. The three friends rose in thankful delight,

and left. Happy with the sudden solution, the manager rushed over to find out just what she had said.

"Amazing. They looked so happy for having been told to leave," he exclaimed.

"I didn't tell them to leave," the waitress replied and smiled her beautiful, self-assured Italian smile. "I told them the barber was a woman."

Everyone understands that "story problems" in mathematics are never true narratives with people to care about or good last lines. They merely set up a calculation and leave their characters hanging. I rescued this story problem of self-referential logic by dressing it up and giving it an ending that had nothing to do with the original question under discussion. Although it provides a way out of the puzzle, it also illustrates the two worlds in which we live: the narrative world and the matter-of-fact world.

The waitress with her personal point of view and her imagination found a new solution to the mathematician's matter-of-fact puzzle by resolving it in a narrative way, giving it a human dimension and a feminist twist. Explaining the inexplicable is one thing that narrative has always done. Noah and the rainbow becomes a story – with an ending. The matter-of-fact observation of Sir Isaac Newton concerning the behavior of light as a wave – as it encounters mediums of different refractive indexes and reflects at equal angles from the interior spherical surface of a suspended drop of water, coming back to the viewer at an angle of forty-two degrees from the original source of light – is not.

Whenever a narrative plot or an explanation is in evidence, it thickens everything like rabbit and mushroom risotto. It forces disparate things together and makes odd "facts" cohere.

For instance, Joel Sternfeld's early photographs from his 1987 book *American Prospects* serve as good examples of what odd facts can create when left unexplained. In these photographs something is either happening before one's eyes or has just happened. As one examines them, questions arise that beg for explanations. But as accurate as his large format photographs are, no explanation is in evidence. One is free to make up reasons for how things got the way they appear to be. One turns into an arbiter and becomes the Rudyard Kipling of the "Just So" stories or the Isaac Bashevis Singer explaining *The Fools of Chelm and Their History*.

In one memorable Sternfeld photograph, a wood-frame house perched on a hill is engulfed by flames as expensive fire-fighting equipment sprays the roof with a jet of water. In the foreground, however, a solitary firefighter in a yellow slicker leisurely inspects pumpkins at a farm stand. Sternfeld's title for the photograph, *McLean, Virginia, December 1978*, answers nothing about why the man is not attending to the roaring blaze. There are no other clues and the viewer is trapped, like the three Italian friends, in trying to form a logical explanation from a few stray pieces. But that is precisely the point of Sternfeld's first book: the inexplicable is a delightful no man's land of reason, and the imagination has free range as long as the picture is devoid of an accompanying narrative.

Later, Sternfeld took a different approach when he recognized the power of the narrative element and gave it an unconventional role. In his 1996 book, *On This Site: Landscape in Memoriam*, the accompanying titles have been extended into labels describing an event in the past that took place on the site. However, in the scenic pictures themselves, no narratives or explanations are suggested. Everything in the composition

Joel Sternfeld, *Gateway National Recreation Area, Rockaway Peninsula, Queens, New York, September 1993* (original in color)

seems settled and at peace, and unlike his earlier work, no immediate questions come to mind from the elements the pictures contain. But knowing his earlier work, one senses that something more is yet to be revealed.

One of Sternfeld's site photographs shows an unoccupied stretch of a beach perfect for swimming, a line of old weathered pilings extending into the calm of a blue ocean, and a clearly delineated horizon on which what appears to be a white pleasure boat is barely perceptible in the offing. The whole scene is bathed in gentle early evening light. His caption has two parts. The matter-of-fact part reads: *Gateway National Recreation Area, Rockaway Peninsula, Queens, New York, September 1993.*

The second part of the caption, the explanatory part, reads:

Almost 300 illegal Chinese immigrants struggled against the pound-ing surf to reach the shore of the United States on the night of June 6, 1993. Ten died of drowning or hypothermia; the rest escaped or were taken into custody.

The immigrants had endured four and a half months of brutal con-ditions in transit before their vessel, the Golden Venture, *hit a sand-bar 200 yards off this beach. They were crammed into a twenty-by-forty foot hold; food and water were scarce; sanitation conditions were sub-human.*

Of those arrested forty-seven were deported to China, thirty were granted asylum, and forty-six were released. At the end of 1995, 147 were still in federal custody. Lee Peng Fei, the suspected mastermind of the failed voyage, had demanded $30,000 from each would-be immi-grant. He was arrested in Bangkok in November 1995.

Once it is read, Sternfeld's extended caption creates a human dimension and puts the photograph into a narrative relief. We see that the matter-of-factness of the photograph and its seduc-tive beauty leads one in another direction and thus disguises the significant story associated with the site. One is shocked to think that the innocent view, suitable for a kitchen calendar, is supposed to symbolize, or contain, or be witness to some horror. Viewers have come to expect that photographs do that because photojournalists and their editors, as well as those who stage public relations events, try to incorporate narrative ele-ments into photographs to help tell their stories. Viewers thus feel that the visual elements of the photograph itself should somehow reveal, or at least be in character with, the purpose for which the photograph was made. But that is exactly Stern-feld's point: objective visual facts or even scenic views are only appearances and do not reveal purposes by themselves; they

have to be coerced. Stories occur at specific places and disappear from their sites with time. What better medium than photography – the medium of the actual, the incidental, the single moment, and the historical slice – to illustrate the way that the where and the when can be separated from everything else? Like the waitress's observation, Sternfeld's extended caption suddenly reveals another explanation, and in so doing creates a story of its own.

Recall again the differences between the matter-of-fact world and the narrative world. In scientific explanations about how the world works, if a major, new fact is accepted, practices change to accommodate it, and the old theory is discarded. Narrative is different. One of its endearing characteristics is that after one learns that a newly found fact proves something other than what was once believed, one does not always not discard the story that explained it, rather, one often treasures it more, believing it still contains other truths. Although narratives gum up the facts and distort reality for their own purposes, they still survive. Mother Goose and Grimms' fairy tales are still in print, as are the *Odyssey* and the five books of Moses.

But the matter-of-fact world persists and intrudes, and one cannot avoid it for long. So one needs to look at the relationship it has with the world of narrative when photography is between them. There is, as with most things, a simplified and a complicated approach.

The voice who can lend most credence to the simplified approach is himself a complicated man, the French poet, Paul Valéry. Valéry had a keen interest in mathematics and philosophical logic and was a revered member of the Académie Français. In January 1939, when the French were celebrating their own 100th anniversary of the invention of photography by

Louis-Jacques Mandé Daguerre, a symposium was held at the Sorbonne. Valéry was asked to deliver a brief lecture. The sixty-eight-year-old master of mind and language had a solid and conventional notion about what photography was. Although he may not have kept up with avant-garde figures like Man Ray, André Kertész, or the young Henri Cartier-Bresson, all of whom had established their names in Paris at the time, he did know some photographers, such as Laure Albin-Guillot, from having portraits made. And, of course, he had a way with words like no one else. He said: "Thanks to photography, the eye grew accustomed to anticipate what it should see, and to see it; and it learned not to see nonexistent things which, hitherto, it had seen so clearly."[1]

Valéry remarked how photography could show with perfect accuracy such things as the way horses actually moved in a gallop or a trot. Such studies of motion in the late nineteenth century by the American, Eadweard Muybridge, and the Frenchman, Etienne-Jules Marey, had been known for decades, and it was part of what most people trusted photography to do. An analogous situation today would be the public's captivation with photographs taken in space. No special narrative is needed for these extraterrestrial marvels to be admired, just the technical captions that are usually provided. As merely seeing what has never been seen before is fascination enough; narrative can wait. Although Valéry believed that photographs could be made to lie as language did, he felt that their inherent optical accuracy could release language from having to "convey the ideas of a visual object with any degree of precision."[2] He wrote: "So it must be agreed, then, that bromide proves stronger than ink, whenever the mere presence of things suffices, whenever the thing speaks for itself without benefit of proxy, that is,

without having recourse to the wholly arbitrary transmissions of a language."[3]

The second approach in dealing with the matter-of-fact world and the narrative world when photography is between them is the more complicated one. This approach might be illustrated by what the Surrealists appreciated about straight documentary photography. To them any attending explanatory narrative stifled the imagination. Narrative was unnecessary: if no story suggested itself, other things still went on. One object in a picture could confront another and create a disjunction similar to the odd elements in dreams. For them, the chaos of the world, like the unpredictability of the subconscious mind, was a readymade collage that photography could enhance with its objective transcription and a certain point of view.

It was not only the Surrealists who followed this track. In 1928, Pierre MacOrlan, the French novelist and journalist, explained another aspect of photography that both the Surrealists and the public in general appreciated. He tried to explain how the medium in the hands of photographers such as André Kertész could be more than a simple record of objects:

[Documentary photography] is unwittingly literary, because it is nothing other than an observation of contemporary life apprehended at the right moment by an artist capable of seizing it.

The greatest field of photography, for the literary interpretation of life, consists, to my mind, in its latent power to create, as it were, death for a single second. Any thing or person is, at will, made to die for a moment of time so immeasurably small that the return to life is effected without consciousness of the great adventure.[4]

The great adventure was not just the return to "life," but having the viewer complete the action. Although the Surrealists were

thrilled to leave the suspension where it was, for most people this coming back from a moment of "death" meant completing the action as a story. Editors and art directors caught on quickly and created visual layouts for their weekly publications that told a story in pictures with the aid of captions or a short text.

In the photographic world, the picture of the arrested moment – the incidental, we might call it – has acquired an elevated status. A scene taken from the flow of time, graced with its self-contained gestures, is something photographers have learned to capture extremely well. Unlike other visual art, in photography the incidental is often the primary reason for the picture having been taken in the first place. This forces one to try to devise surrealistic meanings for it or explain it with a story of one's own making, which allows those beyond the photographer a role in the creative process. Photographers with highly refined senses of spatial arrangement and timing see extraordinary things in front of them every day that are essentially invisible to the rest of the world. But attention to minor incidental events is not exclusively a modern photographic practice, as W. H. Auden points out in his poem, "Musée des Beaux Arts":

> About suffering they were never wrong,
> The Old Masters: how well they understood
> Its human position; how it takes place
> While someone else is eating or opening a window or just
> walking dully along.
> How, when the aged are reverently, passionately waiting
> For the miraculous birth, there always must be
> Children who did not specially want it to happen, skating
> On a pond at the edge of the wood:
> They never forgot

That even the dreadful martyrdom must run its course
Anyhow in a corner, some untidy spot
Where the dogs go on in their doggy life and the torturer's horse
Scratches its innocent behind on a tree.

In Brueghel's Icarus, *for instance: how everything turns away*
Quite leisurely from the disaster; the ploughman may
Have heard the splash, or forsaken cry,
But for him it was not an important failure; the sun shone
As it had to on the white legs disappearing into the green
Water; and the expensive delicate ship that must have seen
Something amazing, a boy falling out of the sky,
Had somewhere to get to and sailed calmly on.[5]

One of the masters of the incidental is Garry Winogrand. He has given the incidental a new importance. As he once put it: "The photograph isn't what was photographed. It's something else. It's a new fact."[6] This is a true complication of Valéry's notion of photography and takes MacOrlan's idea a step further. Although making another fact from a fact sounds like what storytellers do, the Winogrand photographs do not try to form themselves into completed stories. His photographs are somewhere in between the matter-of-fact world and the narrative world. Sometimes they are mere sight gags: at other times they are extraordinary scenes that the most gifted film director could hardly have imagined on his own. The world for Winogrand was too chaotic to comprehend fully, but too rich to reinvent as small, dumb staged events.

Winogrand did talk about his photography, but he did not usually tell stories about individual photographs. In his lectures, when people in the audience asked him why he took a photograph of a certain subject, his standard, but truthful,

Garry Winogrand, *Hard Hat Rally, New York*, 1969

response was: "To see what it would look like photographed." An exasperating answer for those who wanted inexplicable things explained. He would also get another common question: "What is this photograph supposed to mean?" To which he would answer, "The photograph is not my problem, it's yours." Although to some he seemed evasive, he felt it was not his job to hold the viewer's hand or to supply a kind of existential story problem and then shortcut to a neat, calculated answer. He wanted his photographs to have no "answers" and leave their characters and events hanging in them forever.

In contrast to Winogrand, W. Eugene Smith always seemed to have a purpose for his photographs and a story to tell. He understood the power of incidentals but almost always made them subservient to the picture story or the narrative sense of individual photographs. Unlike Winogrand, Smith was a man on a mission, always fighting an uphill battle for one social cause or another. Thus, he could not afford to allow the char-

W. Eugene Smith, *Three Generations of Welsh Miners*, 1950

acters or the events in his photographs to be left hanging, available for any stray or private interpretation. For several years after the Second World War, in which Smith established his name as a daring combat photographer, his personal purpose and that of his editors at *Life* magazine found reconciliation, and he became one of their most celebrated photojournalists, one of their stars. Like a star, he also became one of their most highly unmanageable personalities. More and more he saw the world his own way and demanded a say in the selection process and the layout of his photographic essays. The corporate climate at *Life* magazine eventually made his independent way of working an exasperation to all concerned, and he resigned in 1954.

One might criticize Smith for shamelessly grabbing for

every heartstring he could reach. If he acted as if he were a desperate man, it is because he believed that lives were at stake. Photography for him was not just the mechanism by which visual facts were obtained in order to establish how horses trot. The quest for a compelling narrative affected the way he took, printed, and published photographs. Narrative was an essential part of his only effective tool in changing the world around him: the publication of stories with compelling photographs. His characters were never left hanging and were part of well-planned conclusions.

Perhaps the conventional view that Valéry voiced at photography's centenary is fated to return over and over again, as new generations of non-photographers tell us what they think the medium is, guess at the origin of photographic ideas, and dictate what photographers are supposed to do. But even if photography cannot see the nonexistent things that poetry can, it does not mean the same is true for photographers themselves. After all, if poets, like William Carlos Williams, step out of character in voicing the notion that there are "no ideas except in things," and Wallace Stevens wrote, "Let's see the very thing itself and nothing else," there may be a virtue in seeming to be out of one's assigned role. Going beyond the limitation of visual fact by establishing a narrative is what Smith tried to do in using some of the tricks of propaganda to his advantage. Winogrand found new subjects in suspending the flow of life, but disdained to guide the viewer to a story ending or a surrealistic amusement, and just left the new fact hanging as it formed. Sternfeld discovered that exposing the limitations of only knowing things photographically could be the most powerful device in making the story he wanted to tell more compelling.

As linguistically seductive as Valéry's remarks are, we do not

need to rely solely on those who are only the viewers of photographs. Recall what Winogrand, a true photographer, said: "The photograph isn't what was photographed. It's something else. It's a new fact."[7] This attitude frees the photographer, somewhat, from the tyranny of the original objects or the situations they create. Sternfeld made his point in a radically different way. If Winogrand's and Sternfeld's approaches leave little room for narrative of the kind that Smith employed, they bring us to a higher consciousness about the inherent lack of the narrative element in photography. Beyond the isolated visual fact that Valéry honored, the suspension that incidentals expose or the separation that conflicting captions provide create another theater of display and a way for photographers to respond to the matter-of-fact world in their own voice.

One question that remains is why, in our scientific and technological age, has narrative not been dismissed by fact or even by newly created facts in photographs. Why does it have a value beyond the quaint amusement of discredited explanation? Why is it still a force that photographers chose to assiduously avoid, draw from, or succumb to?

There undoubtedly is a simplified and a complicated approach to the answer. Perhaps the simplified approach is enough for now. Narrative, even though it is pressed into service for other chores from humor to philosophy, does one indispensable thing extremely well. What narrative does better than any other medium of expression is to directly address the question of what we think we know – not about being particles of the matter-of-fact world or elements of a logical puzzle, but rather about being human.

Edward Weston
Point Lobos
1944

Imperfectly Unknown

POINT LOBOS, 1944
A MASTERPIECE BY EDWARD WESTON

IN THE AUTUMN OF 1972, as a green and inquisitive curator, I first began opening solander boxes in the collection of the Art Institute of Chicago. One of the boxes contained Edward Weston's late photographs. Among the perfect prints I found one that was unlike any Weston photograph I had ever seen before. It was not boldly geometric. Rather it seemed atmospheric and pensive, even moody, which was not typical of the Weston photographs I knew. It was solemn and silent, and the hushing voice I felt it had would haunt me for decades. When I came across it, I noticed that its overmat was in pristine condition, meaning it had had little handling, and in fact, I think, had never been shown in our museum.

Except to a few experts, this dark and quiet photograph of Point Lobos has been essentially unknown from the day it was made. Nevertheless, it is one of the most deeply meditative and beautiful photographs that I know in the history of photography.

For most of my career, I did not know what to do with the moody photograph. It did not fit in with the crisp, bright Weston work that I knew so well. Nor did its romantic charge derive from the driving force of his powerful photographic formalism. It was a puzzle beyond the ready answers that a young but very confident curator had in abundance. Even now after many minds have studied Weston's work, it is still not a perfect fit with the style conventionally associated with him, and thus

97

Edward Weston, *Tina*, 1923

retains some of its mystique. It takes a bit of getting used to, because most of Weston's admirers, as well as his critics, insist they know what his work is supposed to be about. In thinking this, they have accepted a certain persona to go with their ideas of who Weston was. The problem is that the persona accepted for the photographer in his late career is identical to an earlier one. That earlier persona belongs to a vibrant middle-aged man who, through his *Daybooks*, would have us believe he was a talented egomaniac with an extensive photographic virtuosity and tireless sexual energy. The mood of this landscape photograph, however, suggests an author of another sort. This dichotomy is the reason why the prints from negative PL44L2 have lived their whole lives in a storage boxes.

The mid-career Weston seems to endure in most general discussions. This is the bold, footloose adventurer whose rest-

Edward
Weston
*Nautilus
Shell (half)*
1927

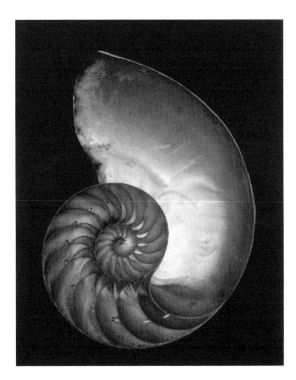

less ambitions lured him away from his family to Mexico in
1924. He was not a loner or an outcast, however. With him
were his oldest son, Chandler, and his ravishing model and
protégé, Tina Modotti.

When Weston returned north, he traveled between Los
Angeles and San Francisco, living in several places, until 1938
when he acquired a permanent studio in the Carmel High-
lands. This is the Weston whose artistic and romantic conquests
released the fettered imagination whenever restricted by soci-
ety or caged by convention. Despite his mythic energy and
large ambition, the fact of the matter is that he, like everyone
else, changed with time and with age.

Edward Weston, *Exposition of Dynamic Symmetry*, 1947

For decades this somber photograph pestered me with its trancelike quietude. Finally, with time and age, I came to terms not only with its melancholic beauty, but with the meaning its enchantment was hiding. It then became the key to unlocking the power, the sense, and the significance of other late work in Weston's career.

The photograph is simply titled *Point Lobos*, 1944, and it belongs to studies Weston made that year of what might be termed cliffsides. Until the exhibition, *Edward Weston: The Last Years in Carmel*, these photographs have never been shown as a group. Weston's many retrospectives and monographs have skipped over them as a series. Perhaps this is because they seem out of character, or at least out of the character assigned to him. Or perhaps it is simply because the cliffside photographs

Edward Weston, *Cats on Woodbox*, 1944

are not as graphically startling as his famous vegetables, nudes, or sand dunes. Unlike his photographs of the 1920s and 1930s, the cliffside landscapes provide no particular center of interest, or magnetic subject matter, nor do they display any overt compositional structure. Although the photographs reveal patterns within the weathered rock, they are not meant to be geometric exercises in natural observation in the way Weston's 1927 shell photographs were.

Almost all of the cliffside photographs were taken in 1944. This is a year that is relatively neglected in discussions of Weston's career. It is the year between his innovative and curious "backyard setups," in 1943 and his separation in November 1945 from Charis Wilson, his second wife.

It is also the year in which his four sons went off to war. And

Edward Weston, *Portrait of Cole Weston and His Wife, Dorothy*, 1945

if one is allowed some latitude in speculation, it *may* have been the first year that Weston noticed a slight, but strange, decline in his otherwise superb health. Within the short space of the four years after 1944, Weston would become so consumed with Parkinson's Disease that he would stop photographing, and ten years after that, on New Year's Day 1958, he would die.

In 1944 and 1945, however, Weston was still relatively active, considering the restrictions that the war periodically forced upon him and every other photographer who wanted to travel extensively or photograph the coast. Besides the cliff-side landscapes, Weston made a number of profoundly felt portraits of his immediate family.

He made more nudes of Charis in 1945, and added to a

Edward Weston, *Nude*, 1945

growing number of cat photographs. These animal portraits were meant to illustrate a book that Charis was preparing on their tribe of semiwild pets called *The Cats of Wildcat Hill* (1947).

Weston's series of cliffside photographs was for him an important aesthetic step forward. The subject served as both an escape and as a vessel for what must surely have been an increasing sense of isolation. Weston was entering a new period of his career. Gradually his photographs were linked to his life experiences and the mix of emotions that they produced. Although his photographs were primarily about a discovery of nature, they were also informed by personal issues. This was a new situation for him. During his two years traveling and photographing on Guggenheim Fellowships (1937–1939), he shaped

Edward Weston, *Granite Cliff, Point Lobos*, 1944

his life to his emotional need to photograph. Now the situation was beginning to reverse itself, and many of his best photographs were being shaped by the needs of his emotional life. In his midcareer, and after, Weston insisted that none of his photographs were indications of his state of mind. This was firstly a strongly felt philosophical attitude and, secondly, a reaction against Alfred Stieglitz's cloud photographs.

The elder, East Coast photographer made his semiabstract cloud studies between 1922 and 1931. Calling them "Equivalents" was Stieglitz's way of indicating that they were parallel expressions, even projections, of his own mental and emotional state. Although Weston made his cliffside photographs darker and more brooding than any of his other work, he refused to admit that they might be reflecting his personal turmoil.

Edward Weston, *Red Rock Canyon*, 1937

He still believed that photography was first and foremost an objective record of what it is possible to see. The discovery of the visual world thus determined any feeling that the photograph contained, and not the other way around. Nevertheless, Weston's photographs were changing, as was he.

The idea of the composition of the cliffsides might be said to have started with a photograph from Red Rock Canyon, made in 1937. In that picture of desert rocks, Weston allowed a surface of stone to spread across the composition in a rather featureless way. The Red Rock Canyon photograph never became a crucial work for him, and Weston left the idea unexamined until 1944, when he let the cliffsides open up in a similar way and spread across the ground glass of his 8 x 10 view camera. Weston was not overbearing in his framing of

Edward Weston, *Stone Crop, Point Lobos*, 1944

them. Perhaps he just expected the myriad components to suggest an internal composition of their own and recover for him an ancient story of granite disfigured by outside forces.

Weston was not the only one who felt akin to the coast cliffs and boulders of Point Lobos. Before Weston arrived in Carmel in 1929, the poet Robinson Jeffers had been communing with them for a decade. Jeffers even learned stone masonry in order to build a house and an adjacent tower of them on Carmel Point. The men were just a year apart in age, and admired each other's work. Of the rocks Jeffers wrote:

> . . . *I have much in common with these old rockheads,*
> *Old comrades, I too have escaped and stand.*
> *I have shared in my time the human illusions, the muddy*
> *foolishness*

Clyfford Still, *Oil on Canvas*, 1950

And craving passions, but something thirty years ago
 pulled me
Out of the tidewash; I must not even pretend
To be one of the people. I must stand here
Alone with open eyes in the clearing air growing old. . . [1]

In the cliffside photographs, Weston's tack was a bit different than the poet's. The photographer now chose to avoid the singular outcrop as a symbol and looked instead to the mass of the cliff. Knowing Weston's biography, one can see the battered cliff as a metaphor for his life in 1944, even perhaps a metaphor for the country's situation. But that interpretation is a bit too facile. If, instead, one examines the photographer's *approach* rather than his *subject*, something more can be detected. In these works, there is no sense of personal rage, as in Jeffers's other poems just before and during the war. Nor is there the graphic tension that would later be found in the work of an Abstract Expressionist

painter like Clyfford Still, even though his flat-field pictures are remarkably similar in composition.

Rather, in Weston's photographs of this period, there is a certain feeling of resignation. Not the resignation that accompanies slow defeat, but the kind another poet, Wallace Stevens, described as writing "pax across the window pane." Perhaps, in Weston's case, a more accurate word is acceptance. One might say that in these pictures, Weston was speaking more to himself than to us. It is as if he were finally ready to stand still and just see what stood before him and not to call upon his considerable virtuosity to command it into a photographic print of line or space. More and more, one can sense that it is tone that came to dominate his photographs of Point Lobos in this period. This resulted in their having a more pronounced mood than in the past. Having solved nothing for himself a year before in the highly directed tableaux photographs or in the portraits of cats, Weston found, at age 58, these photographs to be the entry way into his next period.

Photographically, the cliffsides proved to be a way of dealing with his life of steady decay on Wildcat Hill, an end that in the active, optimistic days of the Guggenheim Fellowships he could not have foreseen for himself. Had he been younger, I suppose, Weston would have taken scores of photographs in this new way. Now, for the older man, a few images of deeper meaning were enough.

Why are these cliffside photographs so neglected if they seem to carry so much emotional weight and meaning for one of the greatest talents of the medium?

One reason is that there have been too many routine publications and inspections of Weston's career, which keep returning to the same famous photographs of nudes, dunes, and

vegetables – many of which are among his best work. Such studies also tend to utilize the same quotes from his *Daybooks* as a way of explaining them. Other exhibitions have helped to refine our understanding of Weston in scholarly ways, but a radically new way of dealing with the late and often obscure works has been lacking, even after all this time.

It should be pointed out that after 1934 the life that was lived between and beyond those photographic icons was no longer conveniently recorded as quotable *Daybook* entries. Weston had ceased writing in his *Daybook* partly because his young wife Charis had become the chronicler of their photographic deeds, and partly because his early morning hours were no longer spent alone at his writing desk. Accounts of his daily thoughts were now fewer and scattered among letters to his friends and family. Thus, they are harder to assemble and consequently do not appear as an aid to understanding the last part of his career.

There is another, more pedestrian reason that the cliffside photographs were neglected. When that pensive Point Lobos landscape, PL44L2, was reproduced for the first time in 1979, it had a chance to make an impression, as it was included in the definitive biography by Ben Maddow. But it was printed in tones so light as to be almost unrecognizable. That first reproduction of the image did not contain any of the emotion with which Weston had saturated the original print. It sat on the page bleached-out and dry of any feeling.

The main reason, though, for the neglect of the cliffside photographs is that few viewers or curators understand what happens to the creativity of great artists as they enter old age. It is understandably an experience that everyone wants to push off to any distant time whatsoever. In a culture that is particu-

larly attracted to youthful themes and activities, one is ill pre-
pared for honoring or even observing the radically different
kinds of existence that older artists create. Apart from keeping
healthy, most of our aging population spends a great deal of
time and energy denying that one is growing old. As Betty
Friedan in her 1993 book, *The Fountain of Age*, astutely de-
scribed from both study and experience: "The problem is, first
of all, how to break through the cocoon of our illusory youth
and risk a new stage in life, where there are no prescribed role
models to follow, no guideposts, no rigid rules or visible rewards,
to step out into the true existential unknown of these new years
of life now open to us, and to find our own terms for living it."[2]

Older artists create a different kind of liberty than their
younger contemporaries believe they have as birthright. This
is a freedom that is more substantial: they realize that no mat-
ter what kind of art they make or in what style they make it
they are accountable to absolutely no one but themselves. A
sense of self-reference, of examining one's own life experience
as a subject, often becomes an underlying preoccupation. The
third period is different from that of youth or middle age, not
so much in degree but in the kind of creative activity. Unlike
the imagination, even a great artist's virtuosity – that is, the way
an idea finds its ultimate physical form – has a limit. When the
imagination advances further than virtuosity can follow, many
creative individuals are trapped in old ways of applying their
skills to new ideas or feelings. It is a perplexing situation that
has no pathological label.

Although Edward Weston serves as an excellent example of
a major photographer who entered old age, the pattern can be
seen in other visual artists, as well. For example, it fits both the
painters Winslow Homer and Claude Monet. It also fits musi-

cians such as Franz Liszt (1811–1886), who developed from a talented child pianist into one of the most famous virtuosi in history.

Liszt's fame was established as a young concertizer and almost all of his best-known compositions were either published or performed before he was forty-five. Harold C. Schonberg writes:

As Liszt grew older, he became more complicated, and he constantly grew as a musician. He remained a complicated man — a mixture of genius, vanity, generosity, lust, religion, snobbery, democracy, literary desires and visions: part Byron, part Casanova, part Mephistopheles, part St. Francis.[3]

Weston did not possess Liszt's fame or social standing. The photographer was not snobbish, devilish, or tall, lanky, or even blonde. But Weston and Liszt, as different as they were, shared a great deal of substance, especially in their level of virtuosity and the character they exemplified in old age. With the proper transcription, one can imagine it is the twentieth-century Weston that Alan Walker, Liszt's definitive biographer, is describing when he writes:

It is only against the deepening shadows of his life that we shall come to understand the true meaning of the music of Liszt's old age . . . the path-breaking compositions of Liszt's later years have been treated by theorists and analysts as if their chief importance were to make a contribution towards the history of harmony. . . . We make a mistake when we detach his late music from the disturbed emotions from which it emerged. He wrestled daily with the demons of desolation, despair, and death, and brought forth music which utterly failed to find its audience.[4]

Like Weston's cliffside photographs, Liszt's later piano pieces

were almost totally forgotten. Only a handful of Liszt's late compositions for piano from the 1870s and 1880s were played during his lifetime. Most all of them had to wait until the 1950s when they were rediscovered by a world that finally knew how to "appreciate his . . . unparalleled ability to draw strange sonorities from his instruments."[5]

Andrea Bonatta, who plays late Liszt pieces on the famous 1873 Eduard Steingraeber piano in Bayreuth, an instrument on which Liszt himself performed, has observed:

For me, these late pieces for piano in no way show any poverty of spirit as has been claimed, and still less any lack of inspiration or creative strength. The only thing that we can say is that many ideas are not taken to their ultimate conclusion. If Liszt had followed through his musical intuitions to the end (as for example in Nuages gris), he would inevitably have been led to use atonal writing. But can one really deny one's own language when you are 60 years old, a language that no one else has used as well, with such ease and improvisation throughout a whole lifetime? The most gifted of pianists was not capable of such a step. The only thing that was within his power was to outline new tendencies and to open up the way for others to follow.[6]

So it may be true of Weston. The photographer also grew more complicated and deepened beyond the caricature and the confessional portrait he drew of himself in his *Daybooks*. Critics and curators did not always appreciate his later photographs. In those photographs that parallel his troubled emotions, Weston employed tonality, as Liszt used sonority, to create moods meant to be consistent with Modernist ideas. But in doing this, Weston would not allow himself to venture too far in the metaphysical direction or to make blatantly psychological photographs.

Like Liszt, Weston could not dismiss the virtuosity that he

had taken so long to perfect, but, unlike lesser talents, he was able to transcend it in order to express a deeper sense of his own existence. It was, of course, the next generation of photographers who benefited the most from knowing Weston and his late work, photographers like Rose Mandel, Wynn Bullock, and especially Minor White. They were able to claim one of the several aesthetic futures that Weston had edged up against.

Now that photography is accepted as an art, one is free to see Weston's photographs as the works stemming from a human life, and not as examples of what the medium can be in a Modernist mode. Weston the man can thus emerge. Even so, one is left to wonder what there is to claim for an artist who works beyond his own virtuosity.

Just because the condition of working beyond virtuosity has no name, does not mean that its description has not been attempted. Wallace Stevens, whose best poetry was written in his later career, recognized this late period and characterized it by giving primacy to the imagination when he wrote (in his 1950 poem "Puella Parvula"):

> *Over all these the mighty imagination triumphs*
> *Like a trumpet and says, in this season of memory,*
> *When the leaves fall like things mournful of the past,*
>
> *Keep quiet in the heart, O wild bitch. O mind*
> *Gone wild, be what he tells you to be:* Puella.
> *Write* pax *across the window pane. And then*
>
> *Be still. The* summarium in excelsis *begins . . .*
> *Flame, sound, fury composed . . . Hear what he says,*
> *The dauntless master, as he starts the human tale.*[7]

Whether one is a poet or a photographer, an expanded self-consciousness of one's existence eventually does come with

age. Great artists often do not deny that they are now fitter to judge than to invent. When poets or photographers in this late period look back and apply their judgment to their experience of the last twenty years, they view an accomplished self who is entering mid-life. When those in the middle period look back, however, they have only a glorious green beginning to draw upon, thus their greater reliance on invention than judgment.

In the third period, artists who once spoke so eagerly as newly-minted masters to the wide world often turn inward to examine what the creative life means not to their admirers but to themselves. In addition to the last piano pieces of Franz Liszt, examples of this inner turning are the aging Michelangelo, in his last *Pietà*, and the deaf Beethoven, in his final quartets.[8] In such cases, one is more an eavesdropper than an intended audience.

The latter part of a late career can be a private realm and the work hard to appreciate for those who expect that art only communicates one sensibility to another. Of course not all artists who recognize that the third period is upon them invert their concentration so completely or seek what seems a hermit's truth. The examples of Milton, Verdi, and Yeats readily come to mind. Nevertheless, the unique core of the third period for great artists is the new freedom they attain, either to actively address an audience about their experiences or to confront the last vestiges of the imagination alone, appearing to do little that speaks to others; "inanimate in an inert savoir" is the phrase Stevens created for this state of mind.[9]

"Inanimate in an inert savoir" is a poetic phrase for what often becomes a real condition despite decades of creative playfulness. It describes fairly well at least one feeling that comes

out of that unknown Point Lobos landscape of 1944, that landscape where nature mixes with a life that is weathering terrible storms of its own.

But to become inanimate in an inert savoir is hardly an admitted goal for most artists in the third period, or their viewers. Despite resistance, the difference shows up when a much younger photographer and an old master stand together and look at the same scene. In Weston's late career there are several stories to verify this truth.

One is told by Dody Thompson, who became Weston's last assistant and shortly afterwards his daughter-in-law through her marriage to Edward's second son, Brett. Dody's story tells of the famous last photograph that Weston took in 1948. That photograph is strikingly different from the hundreds he had made during his many years working on Point Lobos. Spread from edge to edge is a composition of sand and rocks without any perspectival depth, something mildly reminiscent of his cliff-side compositions. It has, however, none of the scar patterns of the dark rocks, and though it is not meant to be printed lightly, it expresses no obvious psychological mood. For Thompson, who assisted Weston, the day seemed unpromising. From what she saw, there seemed nothing from which the master could make a decent photograph. But what could she imagine that he was able to picture in his mind's eye? What he was able feel and see so well in his "inert savoir" was simply the physical results of forces spent.

As Thompson has related, there were two photographers walking Point Lobos that day, two photographers with a difference of lifetimes between them. She was young and vivacious, while he was old and slow. The patient master must have been amused by his assistant's anxious search for almost any-

thing on which to try an exposure. Nothing suggested itself. Weston, however, knew there was a lesson to teach her, even if she did not set up the camera. This is how she wrote the story some years later:

Edward bet me that we would find something of interest if we merely looked down from our low bluff into the next cove, whatever it might be, and walked over to the edge. But it was just a poor nook of dull, dark sand with a few small, uninteresting rocks scattered about. He stood peering down several seconds. I still saw nothing, but in that time he decided how his finished print would look. With absolute certainty of knowledge and economy of movement he set up the camera and tripod and made preparation. While he measured the light I examined the image on the ground glass at the rear of the camera . . . and saw glimmering there, upside down and backwards, a lovely ensemble of silver rocks sailing in pewter sand.[10]

Later, Weston liked to refer to his last photograph as the "Dody Rocks." Perhaps, it was a pleasant memory or just a tease to remind her of the subject that had stared her in the face. Understanding the personal meaning of an image of forces spent was still beyond her youthful experience. Nevertheless, she learned something profound on that day at Point Lobos. She observed "how technique must become . . . instinctive as breath" and perhaps how photographic subjects can be anywhere one needs them to be.[11]

Thompson could not have seen the "Dody Rocks" while she was filled with youth's eagerness to find something worth her film. Weston had learned by experience that, in the end, it is not only the film one tries to please, or the public. He had also learned that his goal as an artist was not limited to the capture or control of the subject. What had come to matter most

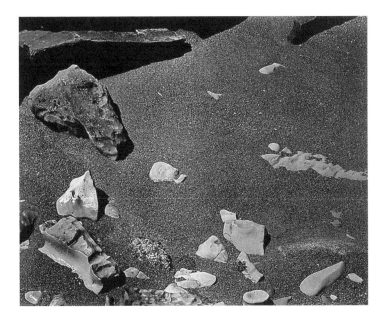

Edward Weston, *Point Lobos*, 1948

for him was the "meaning of the capture," as Stevens once phrased it.[12] At the age of sixty-two, in this seemingly non-descript photograph, Weston had come to know the meaning of capturing what seemed like nothing to everyone else.

It had taken Weston a long time to realize that, at Point Lobos and its adjacent coast, he was living in his spiritual home. Jeffers had recognized this instantly and never left, even preparing a bed next to a window facing the sea, in which to die.

When Stevens expressed the notion of having to search for what in the end seems destined to be, he called its discovery a sense of "unexplained completion." This is, I feel, a sense Weston captured in his last photograph and in the imperfectly unknown cliffside landscape. Stevens captured it as well in his late poem "The Poem That Took the Place of a Mountain":

There it was, word for word,
The poem that took the place of a mountain.

He breathed its oxygen,
Even when the book lay turned in the dust of his table.

It reminded him how he had needed
A place to go to in his own direction,

How he had recomposed the pines,
Shifted the rocks and picked his way among clouds,

For the outlook that would be right,
Where he would be complete in an unexplained completion:

The exact rock where his inexactnesses
Would discover, at last, the view toward which they had edged,

Where he could lie and, gazing down at the sea,
Recognize his unique and solitary home.[13]

Stevens's poem describes Weston and many other artists enter-
ing the last period of their careers. Sadly, once Weston recog-
nized the extraordinary power and freedom of old age, he had
but a few years to work before an incapacitating illness caught
up with him.

During the final decade of Weston's life (1948–1958), he
was inactive as a photographer, but not as a master and host.
Weston welcomed admirers, collectors, and students of every
level into his home on Wildcat Hill. Many remembered their
visits to his studio and what they learned from him without
his having to teach them directly. Everyone who knew him
said he never complained about the debilitating disease that
slowly limited his simple movements as well as his fierce inde-
pendence. Fate had at least spared his mind. Even though

Weston did not have many years in the final period of old age in which to work, he had crossed its boundary and realized what it meant and what his mission was to himself in that future, which for all of us must remain imperfectly unknown.

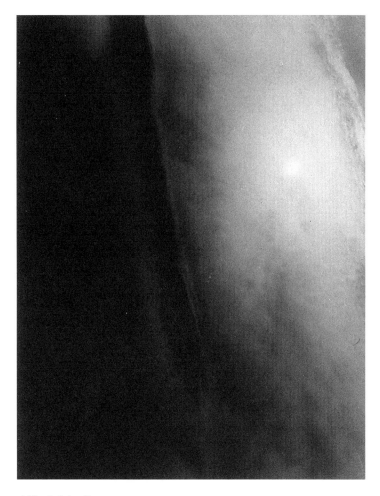

Alfred Stieglitz
Equivalent
1931

A Mind Among the Clouds

ALFRED STIEGLITZ'S EQUIVALENTS PHOTOGRAPHS

AT THE AGE OF FIFTY-NINE, Alfred Stieglitz wrote an article
for an amateur photography magazine, explaining how he had
come to yet another passion in his long career. The new pas-
sion was less about his outgoing discovery of the world around
him than it was about his inner being. It was less about por-
traying the talented artists and writers who comprised his cir-
cle of friends than about revealing his own personality. It was
a passion that suited an older artist examining past experiences
as a source for current work. As Stieglitz entered his fourth
decade as a photographer, he hoped to express his state of mind
by photographing the seemingly insignificant subject of clouds.

His article, "How I Came to Photograph Clouds," began
with a retrospective observation:

*Thirty-five or more years ago I spent a few days in Murren [Switzer-
land], and I was experimenting with ortho plates. Clouds and their
relationship to the rest of the world, and clouds for themselves, inter-
ested me, and clouds which were difficult to photograph – nearly
impossible. Ever since then clouds have been in my mind, most power-
fully at times, and I always knew I'd follow up the experiment.*[1]

Like many young photographers, Stieglitz had been driven by
the technical challenges of making photographs aside from any
guiding aesthetic theory. But as he became more serious about
perfecting his pictures, aesthetic theory gained importance. By
the time he began photographing clouds in earnest, he was

long past being motivated by technical challenges, as he reveals in the article:

Last summer . . .Waldo Frank — one of America's young literary lights . . . wrote that he believed the secret power in my photography was due to the power of hypnotism I had over my sitters, etc. . . . So I made up my mind to answer Frank . . . I'd make a series of cloud photographs . . . I wanted to photograph clouds to find out what I had learned in 40 years about photography. Through clouds to put down my philosophy of life — to show that my photographs were not due to subject matter — not to special trees, or faces, or interiors, to special privileges.[2]

One of the things Stieglitz had learned about photography in forty years was that the very commonness of a subject could serve as the ultimate test of whether he had truly mastered the medium as a tool of vision and personal expression. He went on:

So I began to work with the clouds — and it was great excitement — daily for weeks. Every time I developed I was so wrought up, always believing I had nearly gotten what I was after — but had failed. A most tantalizing sequence of days and weeks. I knew exactly what I was after. I had told Miss O'Keeffe I wanted a series of photographs which when seen by Ernest Bloch (the great composer) he would exclaim: Music! Music! . . . [you] have to write a symphony called "Clouds. . ." And when finally I had my series of ten photographs printed, and Bloch saw them — what I wanted happened verbatim.[3]

Bloch's response was of importance to Stieglitz in refuting the old, but still prevalent, contention that photography was not an art because it was mechanical and dealt only with material subject matter. The characterization of photography as music was important for another reason. In their search for a break

from conventional modes of representation, painters, first in Europe and then in America, began to create abstract works, and justified this new kind of painting as being akin to the emotionally expressive character of music, which was considered to be the most abstract of all the arts.

Something else was different about Stieglitz's cloud photographs. For most of his early career, Stieglitz had preferred to print his negatives on platinum paper, which had a long, rich tonal range and no emulsion layer to interfere with the texture of the paper. In the cloud series, by contrast, Stieglitz began using the ordinary photographic papers available to any amateur. He was deliberately *not* making his prints virtuoso performances on exotic papers:

Straight photography, all gaslight paper, except one palladiotype. All in the power of every photographer of all time, and I was satisfied I had learned something during 40 years. . . . Now if the cloud series are due to my powers of hypnotism I plead "Guilty. . ." My photographs look like photographs. . . . My aim is increasingly to make my photographs look as much like photographs that unless one has eyes and sees, they won't be seen – and still everyone will never forget them having once looked at them.[4]

With this statement Stieglitz abandoned the last weapon of his former arsenal of defending photography as an art and openly declared the primacy of vision over that of material. The careful handcrafting of special prints had earlier been a refutation to the argument that photography was not an art because it was the product of a machine. Stieglitz and a few of his followers had now gained the confidence not to disguise the camera's mechanical basis, but rather to celebrate it. In 1916, his young protégé, Paul Strand, had written that photography's contri-

bution to both science and art lay in its unique means of representation, in its unqualified objectivity. Although Stieglitz's younger photographic followers concentrated on the object quality of architecture or machines to make their point, Stieglitz had his mind among the clouds. His was to be a more cerebral and, at the same time, a more emotional response to the world than theirs.

"How I Came to Photograph Clouds" appeared in 1923, just a year or so after Stieglitz had started passionately photographing them. His excitement of being onto something new kept his first account of his photographs of clouds from being overly philosophical. Despite the death of his mother and the decline of the family estate at Lake George, Stieglitz had reasons to be exuberant in 1923. For the previous five years, he had been living with the much younger and equally talented Georgia O'Keeffe. After convincing O'Keeffe to move to New York by offering her a year to paint without having to earn a living, Stieglitz and his wife of twenty-five years separated. He moved immediately into the studio he had found for O'Keeffe and began one of the most productive periods of his career.

O'Keeffe became his companion, muse, lover, and the subject of his art. Despite her independent mind, the youthful nobody out of Texas would have found it impossible not to follow the demanding posing directions of such a world-famous photographer and powerful force in the New York art world. Besides that they were deliriously in love. The inspiration the thirty-one-year-old O'Keeffe provided the fifty-four-year-old photographer was unlike anything that had happened to him before. It was as if a certain Nietzschean condition had come about; that is, as the philosopher once wrote: "For art to exist, for any sort of aesthetic activity or perception to exist, a cer-

Alfred Stieglitz, *Georgia O'Keeffe*, 1919

tain physiological precondition is indispensable: intoxication."[5]

Although photographing his muse quickly became an ob-
session for Stieglitz, it seems likely that he did not set out to
make an extended portrait of O'Keeffe. He was simply too
lost in the infatuation of making pictures of her to see that
there existed a larger idea for the future. Similarly, in the first
years he photographed clouds, he did not know quite where
the subject would lead him. At first they would be titled *Music:
A Sequence of Ten Cloud Photographs*, then in 1923 he would
call them *Songs of the Sky*; sometime after 1925 he would use

the word *Equivalent*, and in 1927 he called them by the plural form: *Equivalents*.

Thus, in 1922, when the photographs of clouds first began, Stieglitz's life had already taken a crucial turn. He and O'Keeffe had spent two productive summers working at Lake George. Freed from managing a full-time gallery, Stieglitz had more time for his own photography. His pioneering "291" gallery had closed in 1917 due to the strained finances caused by the First World War. Until he had another gallery in 1925, he arranged for other spaces in New York City to exhibit his own work, that of O'Keeffe, and the work of his stable of painters, John Marin, Marsden Hartley, and Arthur Dove, for whom he had become publicist, champion, and father figure.

There are, of course, many more details that make up the complicated story of how Stieglitz's genius was reawakened in the last half of his career. They are mostly anecdotes and tid-bits, such as how he cavorted with Strand's young wife Rebecca and photographed her swimming nude at Lake George dur-ing the same summer in which he first came to photograph clouds. Some small details possess greater importance, how-ever, such as how after 1922 he switched from using his 8 x 10 inch view camera to the more mobile 4 x 5 inch Graflex, which allowed him to aim higher into the sky with ease. There are also the larger stories of O'Keeffe's need for independence and travel, the couple's various health and money problems, Stieglitz's daughter's tragic mental illness, and Stieglitz's occa-sional flirtations or serious infatuations.

These facts and incidents add up to what might be called the external conditions under which Stieglitz conceived of and continued taking his photographs of clouds. Harder to describe with any certainty are the internal conditions that led him to

photograph clouds the way he did. If we compare what Stieglitz first wrote about his photographs of clouds and what they later became for him and his followers, we see an evolution of his intentions. At first, he wanted them to be musical; later he wanted them to represent "the chaos in the world, and of my relationship to that chaos. My prints show the world's constant upsetting of man's equilibrium, and his eternal battle to reestablish it."[6]

His followers, of course, interpreted the *Equivalents* to suit their own needs. One interpretation came in 1947 from the young Minor White, who had visited Stieglitz toward the end of his life in his gallery, An American Place, as had many other admiring photographers. For White there were three modes of expressive photography: the objective, the subjective, and the equivalent. When a photographer sees the subject of a photograph "with regard for either its individuality or its essence," he or she is expressing it objectively. When, on the other hand, the photographic subject causes a mental or emotional reaction, the photographer is expressing it subjectively.[7] For most viewers and critics this covers all cases, but Stieglitz, according to White, took a further step. An "equivalence" is a situation that goes beyond the subjective, even reverses it. No longer is the photographer reacting to something from the outside, but rather projecting what is inside – what has already been established by experience – back out onto the world as if the world were reacting to the observer.[8]

Making an equivalence rather than merely a subjective photograph requires that artists know themselves to such a degree that they dare to shape the world to their own image. The idea of equivalence is thus something that could only have occurred to a colossal ego or to an established, older artist. Stieglitz was

Alfred Stieglitz, *The Terminal*, 1893

both. When Stieglitz arrived at this idea – one of the ideas that changed American photography radically – he was fifty-eight years old. In Stieglitz's own career, this idea was of its season.

To understand why the cloud photographs appeared in Stieglitz's career in the appropriate "season," it is instructive to look at other chronologies of evolution. Consider, for example, this 1588 description of the ideal development of a Japanese tea master. (It is thought to be a description of the life of Sen no Rikyu, the greatest tea master in Japanese history.)

From the age of 15 to 30 leave everything up to the master. From the age of 30 to 40 distinguish one's own taste following one's inclinations in preparation, instruction, and conversation, letting half of all one does be original. From 40 to 50 become as different from one's master as East from West, creating a personal style and gaining a name for

A MIND AMONG THE CLOUDS

Alfred Stieglitz, *Going to the Post, Morris Park*, 1904

skill, for this is the means of revitalizing the way of tea. From 50 to 60 transform tea altogether as one's master did before one, like pouring water out of one vessel into another, and making one's perform-ance as a master the standard in every respect.[9]

Taking the upper limit of these periods for development, we add 30 to Stieglitz's year of birth, 1864, and get 1894, which is right near the end of the period when Stieglitz was making pictorial photographs as many of his colleagues were.

Had Stieglitz apprenticed with an established master in this brand-new field, he would have been toward the end of his

time as a follower.[10] In 1894, he was beginning to distinguish himself with his street and urban photography.

If we add 40 to 1864 we get 1904: nearly the time Stieglitz founded the influential publication *Camera Work* and established what became the "291" gallery.

Stieglitz had clearly been following his own inclinations in preparation and instruction during the preceding decade, and certainly half of what he was doing was original. He would now steadily begin to differentiate himself from his colleagues, who, for the most part, would continue on with what he himself was now leaving behind. His constant crusading for the modern spirit in both painting and photography was an obvious act of revitalization, if not revolution.

If we add 50 to 1864 we get 1914, which is near the time when Stieglitz had broken off relations with most of his photographic colleagues and was as different from them as East from West.

With the O'Keeffe portraits just over the horizon, a period of great transformation was imminent.

If we add 60 to 1864 we get 1924, which brings us just into the period of the *Equivalents*.

The year 1924 was also eight years after Stieglitz had championed the young Paul Strand as the exemplary talent for the future of the art of photography. In his own work, Stieglitz had laid and was continuing to lay the groundwork for altogether transforming photography as an art in his portraits of O'Keeffe. Through a retrospective of his work in 1921 and another two years later, as well as exhibiting with his stable of painters in 1925, he unquestionably had set a new standard in his field.

The arrival of O'Keeffe into Stieglitz's world (temporarily in 1917 and permanently in 1918) revitalized him in the last

Alfred
Stieglitz
From the
Window
of 291
1915

decade of the tea master's chronology. Her entrance into his career was one of the external conditions that stimulated, even caused, his new work. But O'Keeffe's appearance at that time is not the only reason Stieglitz continued to make great photographs. After all, the portraits they made together could have been embarrassing failures or just the mediocre efforts of a photographer somewhat out of practice. Internal conditions would also affect the course of his career.

Stieglitz was still a powerful, if dormant, talent and had been an ambitious artist for a long time. He was also set in his ways. Had he not been, it is likely that the influx of dada in the persons of Francis Picabia and Marcel Duchamp during the First

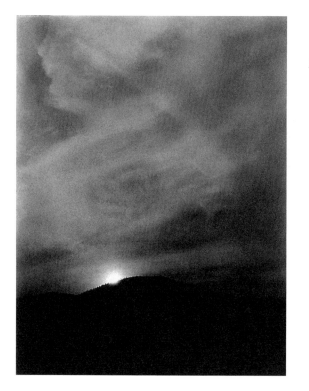

Alfred
Stieglitz
*Later Lake
George*
1922–23

World War would have converted Stieglitz to their fractured and irrational vision of the world. They did not. This is not to say, however, that Stieglitz remained unaffected by European influences; his 1915 views outside the 291 window seem a kind of cubism and his 1919 double-exposure portrait of Dorothy True was a truly fortuitous dada-like mistake.

But, the window views still have a touch of the scenic and the double exposure is not quite up to the level of even ordinary dada high jinks.

If we put any faith in the simple developmental outline of tea masters, we can see that Stieglitz should have been ready to play the transforming role that he did. According to the tea

Alfred
Stieglitz
*Dorothy
True*
1919

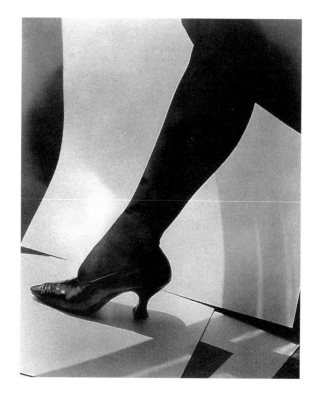

master chronology, during the years between 1914 and 1924, Stieglitz would have been expected to have radically transformed his field altogether. This is what the O'Keeffe portraits and the *Equivalents* actually did. The O'Keeffe portraits are unforgettable because of who she was, the relationship they had, her contributions to his new approach, his skill as a photographer of psychological portraits, his printmaking virtuosity, and the erotic nature of explicit nudity. It was an explosive combination. In these portraits, viewers then and even now can be historian, psychoanalyst, aesthetic theorist, connoisseur, and voyeur without admitting which.

The *Equivalents*, on the other hand, are less titillating, but

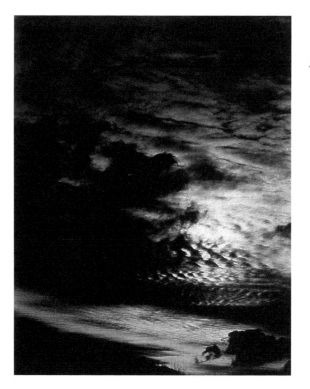

Alfred
Stieglitz
Equivalent
1929

not less significant. If one takes Stieglitz at his word and accepts that the *Equivalents* reflect a state of mind, one might then expect a wild divergence in them all through the 1920s and early 1930s, as he experienced extreme mood swings because of the rocky and tumultuous romance Stieglitz and O'Keeffe created for each other. Perhaps those with dark, agitated clouds are from like emotional periods, and perhaps the serene skies are from the more peaceful summers at Lake George. It is true that the earlier cloud photographs are a bit more calm than those of 1929, the summer O'Keeffe left Stieglitz for New Mexico for four months.

But states of mind are philosophical as well as emotional.

Although describing someone else's state of mind is a speculative affair, the one internal condition of Stieglitz of which we can be certain was his age. Being over sixty, one can expect that his intellectual self might have been in better control of his emotional self. In looking at the *Equivalents*, one can sense a certain sovereignty of consciousness that is not as strong in his portraits of O'Keeffe.

Matching up emotional swings with specific *Equivalents* is a tempting but ultimately futile exercise. The abstraction in these photographs that was so seductive for Stieglitz was not just a matter of aesthetics or the influence of style. At first, it was part of a rhapsodic discovery and then a necessary component of his need for self-reflection. The abstract character of the *Equivalents* gives them a wide latitude to contain other things, things that are difficult to translate from the medium of pictures to the medium of words.

The German poet Rainier Maria Rilke knew this when he wrote:

> *The deep part of my life pours onward,*
> > *as if the river shores were opening out.*
> *It seems that things are more like me now,*
> > *that I can see farther into paintings.*
> *I feel close to what language can't reach.*
> *With my senses, as with birds, I climb*
> > *into the windy heaven, out of oak.*[11]

In Rilke we hear the voice of a man who is no longer searching for an identity in the world. He is confident that he knows well what is rightly his, and his discoveries are more internal. Although others may observe and recognize this sovereignty

of consciousness, it is something that is convincing only in the work of an older artist and proper to it.

Although these cloud photographs appear simple, they are not the results of a younger enthusiast experimenting with abstractions, as Strand did when he first burst onto the scene in 1915 with such things as kitchen bowls and porch shadows. Rather they are, as Stieglitz claimed, philosophical and based on his own particular life experiences. Perhaps the ordinary word "experience" fares better when used by Virginia Woolf, as in her observation: "The compensation of growing old . . . was simply this: that the passions remain as strong as ever, but one had gained – at last! – the power which adds the supreme flavour to existence, – the power of taking hold of experience, of turning it round, slowly, in the light."[12]

If the experiences of older artists keep up with contemporary circumstances, they can be a source for furthering the dialogue with younger artists; if not, the older artists are viewed as relics and their ideas dismissed. Stieglitz certainly understood the contemporary aesthetic circumstances of his time. One of the reasons Stieglitz's *Equivalents* fared as well as they did in the 1920s was not because anyone else particularly identified with his emotional or philosophic urgency to take them, but simply because they were abstract and thus aesthetically up-to-date. The inherent formal abstraction of clouds made Stieglitz's photographs of them both challenging and accessible, so that younger artists and photographers of limited experience could make of them what they wanted.

At the same time that Stieglitz's experience was in step with circumstance, he was at the edge of virtuosity; that is, the skill by which he could conceive of and make beautifully crafted photographs. By the end of the 1920s, Stieglitz's virtuosity as

a photographer had reached its full extent. As far as printmaking went, one might even say he had already begun to regress a little. The O'Keeffe portrait photographs were made on various photographic papers: platinum, palladium, and occasionally silver halide. Stieglitz attended to each print as a separate creative expression: they varied one from another, and were supposed to. The *Equivalents*, on the other hand, are all printed on silver halide paper. Compared to the O'Keeffe portraits, they are more consistent and predictable. While Stieglitz may have griped about the poor quality of Eastman Kodak's materials, the truth of the matter was that the *Equivalents*, being more of a philosophic response to circumstance, did not need individual treatment.

This is not to say that the *Equivalents* are not printed well; they are. Rather, Stieglitz's imagination was leading him beyond virtuosity. What he was searching for he found by looking – that is, by visual contemplation, visual meditation – not by crafting a unique photographic object. Conceptually, this separated him a bit from the influence of painters even though some of his photographs may bear a stylistic similarity. Vision accompanied by a certain conceptual accent was gaining an ascendancy over the photographic objects he produced.

Going beyond virtuosity poses a special problem for a photographer, or any other artist. Through most of Stieglitz's career, development had accompanied searching. At first it was for knowing the world; after that it was for knowing his own imagination. Essential to this searching was a parallel experimentation with the medium of photography: finding out what it could do optically or discovering what kinds of prints he could make. By the end of the 1920s, Stieglitz's search was no longer essentially photographic, and thus he did not need to

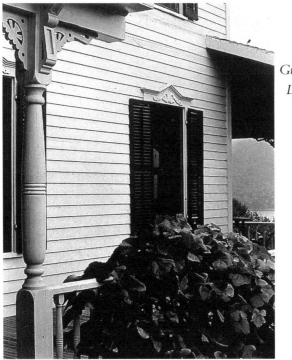

Alfred
Stieglitz
*Porch and
Grape Leaves,
Lake George*
1934

invent new photographic techniques. At this point, when his imagination kept on going, his virtuosity could not follow.

This is not a dilemma that most photographers reach. Most photographers and their admirers see virtuosity as the ultimate achievement: once it is attained, they level off. They do not usually see the potential of another kind of development, and they begin repeating themselves because they are proud and satisfied. Their younger audience does not complain. To be able to take hold of experience, turn it slowly in the light, and then step beyond is a stage few photographers ever reach.

The tea master chronology ends at the age of sixty, and the question becomes: Is there anything more to say about an

Georgia
O'Keeffe
*Lake George
Window*
1929

artist nearing seventy? Confucius says this of himself: "At seventy, I could follow what my heart desired, without transgressing what was right."[13] Writing more to the point is one of Stieglitz's younger contemporaries, Wallace Stevens:

> *After the leaves have fallen, we return*
> *To a plain sense of things. It is as if*
> *We had come to an end of the imagination,*
> *Inanimate in an inert savoir.*[14]

Some of the images of Stieglitz's stasis of knowing, of his letting technique go, reflect on simple, plain things, and are best seen in his last photographs taken at Lake George.

The grape leaves growing on the side porch railing and the post lined up with the window frame with the clean lines of the clapboards leading into it create a beautiful photograph that carries a certain meaning because it was taken not as a younger man's experiment in composition, but rather as an old man's attempt to see the plain sense of things. On the other hand, if one looks at the O'Keeffe *Lake George Window* of 1929, painted when she was forty-two, we see the beauty of a plain thing, not the plain sense of a thing.

It seems a subtle point, but one that makes all the difference between an artist who is forty-two and one who is seventy, between one who is still being swept along with her imagination and one who is contemplating it near its end. Here one can sense that Stieglitz more than O'Keeffe has "the power of taking hold of experience, of turning it round, slowly, in the light."

The plain sense of things is evident in other Stieglitz photographs. He saw the same sweep and movement of wind and light contained in his cloud photographs in the grasses around his summer home.

They too have been made beautiful and their sense plain as they symbolized Stieglitz's state of mind and as he began to consider them to be *Equivalents*, as well. It is an internal condition in which Stevens, echoing Confucius, says, "The point of vision and desire are the same."[15] What searching there is, is more a sorting out of experience and a recognition of the inevitable. Although one can see this in some of the *Equivalents*, it is perhaps clearer in the series of dying poplar trees that Stieglitz took toward the very end of his career.

Poplars are not long-living trees; they do not live as long as oaks. Depending on the frequency of severe weather and lightning storms, they live just a bit longer than people do.

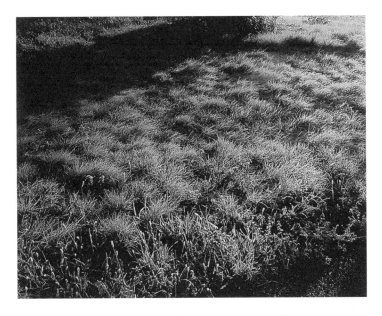

Alfred Stieglitz, *Grasses, Lake George,* 1933

That the old poplars at Lake George, which must have been as old as Stieglitz himself, were dying had a special meaning to him as an artist in old age, a meaning that they could not quite have had to anyone younger. This is something that one can feel in his best photographs of them.

At the same time, beginning in the early 1930s, that Stieglitz was making photographs of the poplars at Lake George, he was also making views of New York City from his apartment on the 28th floor of the Shelton Hotel.

These cityscapes are well known, and seem to have appealed to viewers, admirers, and later to curators as being more modern than the poplars. These two series, however, deserve to be seen together, for they strengthen each other. After all, they are both about the inevitabilities that would be pestering an old

Alfred Stieglitz
Lake George
Poplars
1935

photographer like Stieglitz: the skyscrapers are images of the unstoppable progress around him and the poplars are documents of decay.

Stieglitz had photographed dying trees before, chestnuts and a maple, but he was not a young man when he made them; he was nearing sixty.

These earlier trees are more agitated, more resisting. Now that he was seventy, the poplars seem more resigned to their fate. Their struggle seems to be over. The inevitable seems at hand.

Of course, if the inevitable seems at hand, it means it has not quite arrived, and Stieglitz allowed himself second thoughts. Among his last photographs is one of a young poplar dated

Alfred
Stieglitz
From the
Shelton, West
1931

1937, which is the final year in which he made photographs.

Was he trying to make another start? Perhaps it was just a reaction to an inspiring summer day like the one that must have occurred for Stieglitz in the summer of 1922 when the world and his imagination were full of possibilities. Perhaps other external conditions ruled; perhaps he had yet another younger woman on his mind.

Alas, this young tree signals that things are never quite so perfect as scholars, critics, and storytellers would have them be, and its appearance gives the viewer a choice as to how to demarcate the end of Stieglitz's photographic career. It could end as Wallace Stevens says in an "inert savoir" or as Dylan Thomas wrote in "Fern Hill": as "happy as the grass was green."[16]

Alfred
Stieglitz
*The Old
Maple, Lake
George,* 1926

Whichever end one chooses, one can see the special place in
Stieglitz's long career that first the photographs of clouds and
then the poplars occupy. If they are not full of fight and wild
discovery like the work of his younger contemporaries it is
because they contain a deeper sense of an artist's inner being as
it projects itself back out into the world. Such a sentiment is
not uncommon to great photographers in old age, or to poets,
as Walt Whitman demonstrates when he writes:

> *To get the final lilt of songs,*
> *To penetrate the inmost lore of poets — to know*
> *the mighty ones,*
> *Job, Homer, Eschylus, Dante, Shakespeare, Tennyson, Emerson;*

Alfred Stieglitz, *Young Poplar*, 1937

To diagnose the shifting – delicate tints of love and pride and
 doubt – to truly understand,
To encompass these, the last keen faculty and entrance-price,
Old age, and what it brings from all its past experiences."[17]

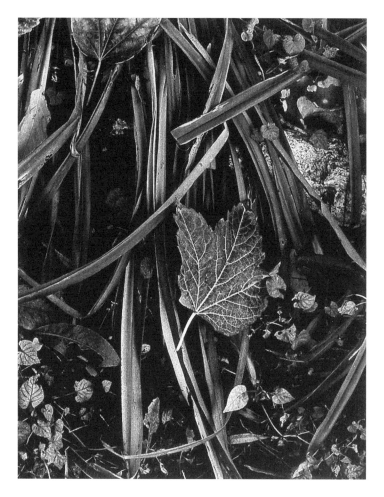

Paul Strand
Fall in Movement
1973

Paul Strand's Fall in Movement

I

Golden leaf after leaf
falls from the tall acacia.
Summer smiles, astonished, feeble,
in this dying dream of a garden.
　　　　　　　　– from "September" by Hermann Hesse

WHAT IS THERE to say about an autumn leaf? The range of
possibilities depends more on the observer than on the leaf
itself. Beyond the botany, what can be said comes from a poet's
realm, frequented by everyone from lyricists to the most
revered tea masters of Japan. Photographers also come and go,
leaving behind calendars and their private works of art. This is
no surprise, since ephemeral matters are their stock in trade.
Welcome or not, photographers have been tourists long enough
that there are now more color slides of leaves than poems.

What then is there to say about a photograph of an autumn
leaf, especially one in black and white? Beyond some diagram
of composition, the answer to this question depends on the
photographer who made it. Of Paul Strand, there is a lot to say.
Of the leaf centered in his 1973 *Fall in Movement*, there is less.
We can at least say that the leaf could not have dropped from
one of Strand's beloved cherry trees; the shape is too much like
a maple. Although many kinds of foliage can be identified
through photographs, that line of inquiry only makes an inven-
tory list. What the leaf might have meant to the photographer,
who did no gardening and did not know the nomenclature of

Paul Strand
Blind Woman,
New York
1916

what flourished within the undergrowth, is a question with a larger answer.

The still-life photographs Strand took in his garden during the last two decades of his life are not as famous as those from his other series: his abstractions, his details of machines, his buildings and landscapes of the Southwest, his documents of Mexico, or his portraits of village life. The reason is that there were never enough garden photographs in one place at one time or for very long. Perhaps Strand felt that these were part of a series that he had not completed. When they did appear, Strand, and others after him, mixed them in with his other series.[1] Only in his last years did he publish them as a limited

Paul Strand
Porch Shadows
1916

edition portfolio, choosing just six, none of which was among his last photographs.

Paul Strand did not begin his photographic career by pursuing nature as a subject. As a native of New York's Upper West Side, he was catapulted in 1916 at the age of twenty-six into Alfred Stieglitz's elite circle of cosmopolitan artists. His candid portraits of street people and his close-ups of kitchenware and porch shadows were praised as radically inventive photographs.

His close-ups were even extreme enough to satisfy an avant-garde taste for "cubistic" abstractions. In 1920 his close-ups included a rock formation and in 1922 a mullen plant. These natural designs now replaced his artificial still lifes. By 1925,

Paul Strand, *Gaspé*, 1929

he felt he could escape the city summers and not worry about losing the income that an extended vacation in the country-side of Maine would cost. There, on Georgetown Island, he became infatuated with organic design and the natural structures they revealed.

During subsequent vacations to Maine in the company of the painter John Marin and the sculptor Gaston Lachaise, Strand's summer infatuation became a near obsession.[2] Although the irises of the Lachaise garden were close at hand, he sought subjects that were further afield. In 1928, while photographing on a breezy shore, he made a marvelous observation. As he recalled years later, it was "a bit of invaluable knowledge good for a lifetime of work."[3] Whenever the breeze abated, the twigs and shoots resumed their previous positions so exactly that if he

opened the shutter only during lulls his negatives would be as sharp as if no wind had pestered him at all. The technique worked, and after discovering the trick, Strand must have felt at one with both nature and his gear, as he kept a sailor's watch across the meadows for approaching puffs.

Having extracted a secret from nature, he gained a working confidence in his abilities, expanding his horizons, as well as his philosophic approach. The next summer vacation found him on the remote Gaspé Peninsula of the Province of Quebec where he took his first photographs of open expanses.

Life in Gaspé affected him by the clean expression of its utility. The inhabitants had built their wood-frame houses not to escape urban stress or to test aesthetic theory; they were there as survivors of an ancestral tradition, still making their living from the sea. On this rugged coast, a new clarity began to dawn. Strand saw that life on Gaspé was not divorced from nature as it was in New York City. Nature had an immediate connection to human existence. In the 1920s, Stieglitz had already gone back to photographing nature, but with a different end in mind. In his photographs of clouds and landscapes, Stieglitz adopted a subjective approach, openly equating external nature with an inner spiritual condition. Strand's more objective attitude reflected nature in the external aspects of the culture it contained. Strand began to see a wholeness to recover in out-of-the-way places. Increasingly, he sought not just a surface design but larger intangibles. During the long exposures of his camera, a settled permanence, a residual core of being, became the subject of the photograph.

Strand's empirical notion of the world took priority over his subjective and intellectual self. He disciplined his work in such a way that his still lifes of natural or man-made objects

Paul Strand, *Mr. Bennett, Vermont,* 1944

bore no sentimentality, nor did they refer back to specific aesthetic theories in the overt way his earlier abstractions had. Although he was passionate about exploring the world, Strand, unlike Stieglitz, was convinced that photographs should not be primarily about the photographer. As he said later, "The thing I see is outside myself – always. I'm not trying to describe an inner state of being."[4] This attitude suited his reserved personality, which his associates more pointedly described as remote, austere, or suspended.[5]

In the 1920s, Strand concentrated on buildings, objects, and landscapes. When people did appear in the next decade, during his documentary work in Mexico, they were in candid street shots taken with an angled mirror hidden on his lens.[6]

In the mid-1940s, Strand made his first direct, head-on portraits of strangers who had agreed to pose. If a few of them seem as distant as tombstones, that is because Strand strove to reflect their individual stoicism and an existence independent from his own.

Thus, Strand came to face, as many scientists of the period had, the paradox of an observer trying to develop a technique so objective that it eliminated not only its own character but its very presence.

II

> . . . *men come to build stately sooner than to garden finely,*
> *as if gardening were the greater perfection.*
> > – from "On Gardens" by Francis Bacon

More than thirty-five years after taking his first natural still lifes, Strand was able to purchase a house with a garden of its own. As Strand was no ordinary photographer, his was no ordinary garden. Visitors to La Briardière, the Strands' home outside of the village of Orgeval, France, have observed that the garden was "admirably wild."[7] Stately and fine were not quite the adjectives to describe the kind of perfection that his third wife, Hazel, with instruction from her French assistant, had brought it to. At Paul's insistence, some of the garden was kept in a partial state of decay. Visitors remarked that dead tree branches were not removed until they had completely fallen, and that leaves were left wherever they landed. Shoots from the trunk of a willow tree were left untrimmed and free to follow their natural directions.[8]

Before finding this secluded property west of Paris, Strand had not actually expressed any desire to escape the life around him. He had moved to Paris in 1950 to avoid the repressive

153

McCarthy era in the United States, and he had spent three busy years publishing a book on France and taking the photographs for another on the Italian village of Luzzara.[9] By 1954, when the Strands completed the remodeling of La Briardière, it must have seemed the perfect place for their retirement. It was peaceful and close to friends, but not too distant from the capital. Its garden was also Hazel's first, replete with espaliered and freestanding pear trees. In addition, it had established rose bushes laid out in rows perpendicular to the stone façade of an old fruit barn that had previously been converted to a house. A flagstone driveway with a large wooden gate and a courtyard for playing boules completed the entrance. The property was big enough that arrangements were made with a French couple to maintain it all.

Strand was not a man who could take the easy life for long. His energies kept pace with his ambitions, and the good health that he had enjoyed throughout his life was still abundant. He could not just sit and watch his property being tended, nor could Hazel work constantly in the garden. In quick succession, with Hazel's encouragement and planning, they shipped out year after year to take on extended photographic projects on the Isle of South Uist in the Outer Hebrides, and in Egypt, Romania, Morocco, and Ghana.

In 1968, at the age of seventy-eight, Strand's extensive photographic trips were over. The garden now served as his last preserve for thinking and wandering about. Sequestered within high stone walls, he was provided with a sufficient amount of domesticated nature to stimulate his imagination and test his failing eyesight and declining health. Would lugging around his heavy camera be worth the effort? Strand need not have worried, if he did. His restricted range only served to add a

touch of something once avoided: an appreciation for his own personal feelings and self-reflected thoughts.

As he entered his eighties, Strand's health began to suffer, first from cataracts and finally from a debilitating bone cancer. He saw the seasonal cycles of the garden with a new urgency, and for the first time his photographs bore metaphoric titles like: *The Apple That Fell, The Garden of Eden*, and *Things Passed on the Way to Oblivion* (both 1973).[10] For over fifty years, he had abhorred such titles, but now they were frequent: *Iris Facing Winter* (1973), *Great Vine in Death* (1973), or *Legion d'Honneur des Forêts* (c.1973).[11] If these garden photographs were to become their own special subject during Strand's last years as a photographer, perhaps he felt they needed such titles to distinguish them from commercial calendar photography. After all, every photograph he had taken was meant to bear larger meanings than what seasonal mementos could provide. More likely, such titles were meant to differentiate his sympathetic, but objective, approach from the unfelt factual renditions of others who made evidentiary and scientific records. Perhaps, though, his resistance to such titles was simply no longer necessary. Strand had kept his faith in objective observation longer than any living photographer. Now, he permitted himself to point out interpretations that he did not want to be lost, indicating that conventional subjects could still address matters of enormous complexity.

True to an inner drive that had sustained his long career, Strand wanted to put yet another book together. One idea he considered was an old one that had occurred to him sometime after the mid-1950s when he first began to photograph his garden. He had thought of calling this book *A Bouquet of France*. In it, he wanted once again to link nature with culture,

this time by alternating the Orgeval photographs with his portraits of French intellectuals: Sartre, Cocteau, Braque, Picasso, and Malraux, among others. But the project attracted no publishers. Now almost two decades later, he considered publishing the garden photographs by themselves.[12] This last selection would most likely be his final book. Unlike his previous publications, however, this subject was much closer to describing his own state of mind. The book itself would be an enormous change for Strand, and perhaps this was why he procrastinated. But in truth, he had other distractions. His house was full of the activities surrounding the assembly of a comprehensive exhibition of his work and the printing of four portfolios. Sadly, *The Garden Book* was beyond his strength to finish.[13] When he died in March 1976, it was left in pieces.

III

The one red leaf, the last of its clan,
That dances as often as dance it can.
　　　　　 – from "Christabel" by Samuel Taylor Coleridge

It is not a farfetched idea that by leaving *The Garden Book* unfinished Strand kept his psychological future open.[14] All of his other projects at the time were retrospective. Whether or not this was his design, the fact of the matter was that as he devoted himself to the completion of his last four portfolios, he had little energy left for *The Garden Book*. In 1975, he spent some time in New York City undergoing chemotherapy. There he made a photograph of an artificial bird that he had set on the bars of a window grating.

Strand entitled it *Bird at the Edge of Space*, and it seemed as if he knew he would never take another photograph. When he returned to Orgeval, he was dying.

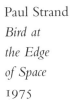

Paul Strand
*Bird at
the Edge
of Space*
1975

We can only speculate what Strand's imagination was like during the last years he was able to make photographs. We can be certain that it was pestered by more than the sea breezes of summer days in Maine. Those were problems of finding new techniques, the problems of a younger man who in the process of solving them sought his own identity. When he found his discipline, he found his identity and dedicated himself to exploring a world outside the one he was familiar with. If his imagination were now to entertain old tricks and techniques, it would not be out of the curiosity of invention but rather to add unexpected meaning.

Only after Strand retired from his foreign travels, and the

garden became his only subject, did he begin to concentrate on an inner world. Although he was not in practice, he was not without some experience in facing what he felt about himself and putting it into photographic form. Expressing a personal state of mind had surfaced once before in several portraits taken of his first wife, Rebecca. Now he had a second, later reason to give it voice. No longer was he addressing a subject that was as distant as the hard scrabbling for life on the Outer Hebrides. Of necessity, he was limited to the very place he did his private thinking and wandering about, to an intimate part of his own life.

Like other great artists in old age, whenever Strand faced himself in his last work his imagination was freighted with the authority of experience. By checking off each new intuition against some memory map of well-known paths and *culs-de-sac*, he saved himself from the repetitions of complacency and the false starts of momentary innovation. But, after sixty years, the question was: What province could his imagination still discover?

Look at *Fall in Movement*. In it we see the well-worn metaphor of a fecund summer's end. But is that simplicity all Strand had in mind? What about the title? Turn the photograph on its side, ninety degrees in either direction. In an awkward way the leaves still form a picture with what surrounds it, but a change more subtle than the rotation occurs. What dynamic life the single leaf within the composition had, it loses. Turn the photograph upside down and the leaf at the center appears to have been tossed in with a chaos of falling forms. The balance of the composition is not right; the leaf no longer composes the wildness around it. Yet, when properly oriented, it regains the illusion of being suspended ever so slightly above what is underneath.

FALL IN MOVEMENT

Although top can be confused with bottom in this photograph, Strand had not made pictures that could be turned in this way for almost fifty years. Only in his early abstractions and close-ups did he deliberately turn or tilt the composition. And in only one known instance in 1926 did he actually turn a composition upside down.[15] All that occurred when he was still searching for what photography could do. Now he was an old man after a settled, serious career, which makes us wonder: What sense of finality is this that would play with such illusions? What truths are being sought out or avoided?

If we see such illusions in *Fall in Movement*, we might postulate that Strand had reached a realm beyond kitchenware, breezy shores, or village populations. This imaginary Gaspé fronted the oceanic expanse of true self-expression. But, if yet another clarity was dawning late in his career, we have only a handful of late garden photographs in which to prove it. Of all his late garden pictures, this particular photograph, with its leaf so certain of its tentative balance, entices us to make our own conjectures. Claiming it for our own imagination, we speculate that, as in Maine and on the real Gaspé, Strand made yet another marvelous observation: each illusion eventually portrays the truth it alters.

Coming upon this idea prompts us to ask if another career for Strand could have begun with this singular photograph. If so, this new career could have been based on a quest to find out whether illusion is a confusion of subjective expectations or a mechanistic part of the phenomena that accompany objective observation. Asked another way: Did one need to return to Stieglitz's approach of investing the natural with the subjective or go even further in the opposite direction? Certainly a photographer as skilled as Strand could tentatively examine

such a paradox without first altering the kind of photography that he had come to stand for. But after a few initial probes, he would be called upon to choose up sides and consider a radical change. If such were the case, this situation may have reminded him of what he faced around 1916 as he was renouncing Pictorialism for Modernism. But even if Strand had decided to change his work beyond the new titles he proposed, such a change would have been nearly impossible. As so often happens, the old photographer was ill-equipped to pursue the new idea, and not just because of age or health or even of curiosity. Taking on such a challenge after conquering the continent of objective observation would be like leaving behind all he had so firmly established. Changing now would require a completely different set of skills.

The vision and technique that Strand had so fully under his command had taken a long time to develop. His virtuosity in photography was legendary and was not something that now could be traded in for something else. Neither could he deny his lifelong habits – his slow, thick patience waiting out shifting winds and xenophobic subjects; his austere eye meticulously adjusting, measuring, and refitting the few elements he needed, reversed and upside down, in a ground glass frame; or his judgment experimenting day after day with old photographic printing papers in conjunction with new combinations of exposure, development, and gold toning, all to produce a single, precious print.[16] He had inherited this procedure from Stieglitz. It was a craftsman's method that responded to materials as well as an intellectual approach: the "pure expression of the object," a phrase one of Stieglitz's associates, Marius de Zayas, had coined back in 1913.[17] This method and idea had started the young Strand off by providing him with a founda-

tion for perfecting a "straight" approach to the medium. But if illusion were a path that now led indirectly to a truth, was his particular virtuosity the proper vehicle to get him there?

Elsewhere many photographers and artists in the United States and Europe were beginning to deny the need for craft and virtuosity at all. They did not bear witness to an objective world or produce any precious prints. Often they did not even make the ordinary photographs they used. Disembodied images consumed their thoughts, as did theories about their reproduction and dissemination. They worked easily with illusion and conception, in a way that made the once radical idea of focussing obsessively on objects seem dated if not obsolete. With these new artists, Strand was completely out of step. If Strand's work was sincere, then irony was fashion; if well founded, then fantasy was flying high. But it was not Strand's fault that he remained steadfast to his ideals. Such disjunctions have always been among the difficulties of long, active careers examined by the light of youthful innovations.

If a private garden west of Paris were not the place that could revolutionize photography, it was still a place for the imagination to spar against one's own set notion of the world. That much we must give the old Strand credit for. After all, it was his imagination and not the toil of the gardeners that found a way to tip the whole world upside down, catch it in the fall, bring it right around again, and suspend it in a single leaf.

Such an acrobatic trick seems less convincing when performed by healthy young photographers, despite whatever wit their technical tour de force may have. Something real must be at stake to postpone death by an illusion and reshape nature with a state of mind. And it is at this point that Strand demonstrates that if his last works were to be honest, he could not go

on eliminating his own presence, no matter what the habits of his long career had been.

Fall in Movement is not the kind of morbid resignation indulging in pathetic self-expression that one might expect of a lesser artist. Strand still had his discipline intact. Yet, one senses that Strand was at the edge of a vast new space that looked out to a horizon on which expressions of self-consciousness awaited. Whatever the temptations might have been, Strand knew he could not quite get there except in moments stolen in his garden. After all, he was ending a career, not beginning one. He was not on the garden's endless, cyclic track of time. For him time was finite and linear, and the gravity of death was real.

In one last look at *Fall in Movement*, ask yourself: Is this photograph only about the gravity of death or is it about the death of gravity as well? As we look, we find the old photographer acknowledging the first interpretation, then catch him musing on the second, in a possibility of pure illusion. If this light touch tries to suspend ephemeral matter from some common destiny, we realize it is because Strand himself was not ready to retire. He creates for himself his own dispensation, because age had not slowed his imagination to a halt. Although his imagination has kept pace with its season, it has also kept its distance. Renewed by the fears, as well as the hopes, it still finds large meanings in such simple things as autumn leaves.

Notes to the Text

BRASSAÏ

Adapted from a lecture delivered at the Art Institute of Chicago on May 12, 1998, in conjunction with the exhibition "Brassaï and Company."

1 Brassaï, *The Secret Paris of the 30s*, translated by Richard Miller, (Pantheon Books, New York, 1976), p. 4 (unpaginated).

2 Ibid., p. 34.

3 Mention of Nietzsche is in *Conversations avec Picasso*.

4 Walter Kaufmann, *Nietzsche: Philosopher, Psychologist, Antichrist*, fourth edition (Princeton University Press, Princeton, New Jersey, 1974), p. 8.

5 Friedrich Nietzsche, *Ecce Homo* (*Thus Spoke Zarathustra*, section 3), from *Basic Writings of Nietzsche*, translated and edited with commentaries by Walter Kaufmann, (Random House, Modern Library Edition, New York, 1992), pp. 756–757.

6 Brassaï, "Souvenirs de mon enfance" in *Brassaï* (Éditions Neuf, Paris, 1952), p. 1 (of unpaginated text).

7 Ibid.

8 Ibid., p. 3 (of unpaginated text).

9 Brassaï, *Brassaï: Letters to My Parents*, translated from the Hungarian by Peter Laki and Barna Kantor (University of Chicago Press, Chicago, 1997), p. 108.

10 Ibid., p. xi.

11 Henry Miller, Introduction to *Histoire de Marie*, quoted in Brassaï, *Brassaï: Letters to My Parents*, p. xi.

12 Henry Miller, *The Tropic of Cancer* (Grove Press, Inc., New York, 1961), pp. 170-171.

13 Henry Miller, quoted from an undated letter to Frank Dobo (dated only "Sunday" and probably 1932 or 1933), Brassaï Archive, Paris.

14 Henry Miller, quoted from a letter to Frank Dobo dated July 27, 1933, Brassaï Archive, Paris.

15 Henry Miller, letter to Frank Dobo dated July 27, 1933, Brassaï Archive, Paris.

16 Henry Miller, *The Tropic of Cancer*, p. 171.

17 Alexandre Trauner, interview conducted by Maria Morris Hambourg in Paris recorded on tape in 1985, a transcript of which is in the Departments of Photography at the Art Institute of Chicago and the Museum of Fine Arts, Houston.

18 Brassaï, *The Secret Paris of the 30s*, p. 6.

19 Jean-Jacques Rousseau, *Reveries of the Solitary Walker* (Fourth Walk) (Penguin Books, London, 1979), p. 79.

20 As Nietzsche himself described the area: "In these circumstances one has to live at Nice. This season it is again full of idlers, grecs, and other philosophers – it is full of my like. . . . The days seem to dawn here with unblushing beauty; never have we had a more beautiful winter. How I should like to send you some of the coloring of Nice! It is all besprinkled with a glittering silver gray; intellectual, highly intellectual coloring: free from every vestige of the brutal ground tone. The advantage of this small stretch of coast between Alassio and Nice is the suggestion of Africa in the coloring, the vegetation, and the dryness of the air. This is not to be found in other parts of Europe." (Friedrich Nietzsche, "Letter to Seydlitz, Nice, Pension de Genève, February 12, 1888" from *The Philosophy of Nietzsche*, edited with an introduction by Geoffrey Clive with translations from the Oscar Levy edition, (Meridian, New York, 1996), p. 92.)

21 Friedrich Nietzsche, *Thus Spoke Zarathustra: A Book for All and None*, translated with a preface by Walter Kaufmann (Penguin Books, New York, 1978), p. 10.

22 Johann Wolfgang von Goethe, *Faust*, part two, act two, translated with an introduction by Phillip Wayne (Penguin Books, New York, 1959), p. 105.

23 Ibid., p. 79.

24 Quoted in Gilberte Brassaï, "Biography", in the Fondacio Antoni Tapiès catalogue, *Brassaï* (Tapiès Foundation, Barcelona, 1993), p. 217. This material is taken from a similar "Biography" by Gilberte Brassaï published in Kim Sichel, *Paris la nuit, Paris la jour*, catalogue essay (Musée Carnavalet, Paris, 1988), p. 74.

25 Brassaï, *Brassaï: Letters to My Parents*, p. 224.

ANDRÉ KERTÉSZ

Adapted from a lecture delivered at the J. Paul Getty Museum on April 23, 1991.

1 I am grateful to Sandra S. Phillips for her researches on Kertész and have used them throughout this lecture. For her published work on this subject see Sandra S. Phillips, David Travis, and Weston J. Naef, *André Kertész: Of Paris and New York* (Thames and Hudson, New York and London, 1985) and her doctoral dissertation *The Photographic Work of André Kertész in France, 1925–1936: A Critical Essay and Catalogue*, 1985 for City University of New York, available through University Microfilms International, Ann Arbor, Michigan.

2 After eleven soirées, Slivinsky lost faith in the group's activities when the facade of his gallery was defaced with "Merde pour l'Esprit Nouveau! Tas d'idiots," see Michel Seuphor, *Seuphor*, ed. Herbert Henkels (Fonds Mercator, Antwerp, 1976), p. 69.

3 March 12, 1927.

4 Seuphor lived at the Hôtel des Terrasses, 74, rue de la Glacière, from 1926 to 1929. Other resident artists were Gyula Zilzer, Lajos Tihanyi, and Gyula Halász, known as Brassaï. The French writer Raymond Queneau also lived at the hotel around that time.

5 *Het Overzicht.*

6 Michel Seuphor, *Seuphor*, p. 313.

7 Seuphor revealed this fact in our conversations and in interviews.

8 August 19, 20; September 2; November 30, 1926; January 1; January 10, 1927.

9 Seated around the table clockwise are Mondrian (holding the publication), Seuphor, Zilzer, and an unidentified man.

10 Bertrand Poirot-Delpech, *Montparnasse: The Golden Years,* (Bookking International, Paris, 1990), p. 5.

11 Quoted in Nancy Troy, "Piet Mondrian's Atelier," *Arts Magazine*, 53, 4 December 1978, pp. 84-85.

12 Recorded as a 1959 memoir of Mrs. M. van Domselaer–Middelkoop, widow of the Dutch composer Jakob van Domselaer in Nancy Troy, op. cit., p. 82.

13 Quoted in Nancy Troy, op. cit., footnote 11, p. 87.

14 For floor plans see Cees Boekraad and Rob de Graaf, "Mondrian

maquette: Nieuw onderaoek naar het atelier aan Rue du Départ," *Archis*, May 1988, pp. 28–37.

15 Michel Seuphor, *Piet Mondrian: Life and Work* (Harry N. Abrams, New York, 1957), p. 158.

16 Ibid., p. 86.

17 Ibid., p. 144.

18 This publication appeared in April, 1927.

19 This recognition was something Kertész desired for a long time and its delay naturally famished him for any glory and adoration he could get. But at long last it happened and he was proud. In returning to Paris from New York in 1963 to attend an opening of an exhibition of his photographs at the Bibliothèque Nationale, Kertész did not even recognize Seuphor, who played a brief but vital role in his early development. Those days and that friendship were gone forever.

20 Quoted in Mildred Friedman, ed., *De Stijl: 1917–1931: Visions of Utopia* (Phaidon, Oxford, 1982), pp. 82–85.

21 Quoted in Nancy Troy, op. cit., p. 83.

CURIOSITY AND CONJECTURE

Adapted from a lecture delivered to the Midwest Center of the American Academy of Arts and Sciences for the 1756th Stated Meeting on October 16, 1993 and reprinted in Bulletin of The American Academy of Arts and Sciences, *vol. XLVII, no. 7, April 1994, pp. 23–45.*

1 Oscar Wilde quoted in Jonathan Williams, *In the Azure over the Squalor: Ransacking & Shorings* (Gnome Press, Frankfort, Kentucky, 1983), p. 27.

2 Story related in Helmut and Alison Gernsheim, *The History of Photography: From the Camera Obscura to the Beginning of the Modern Era* (McGraw-Hill Book Company, New York, 1969), pp. 23–24, which cites William Sanderson, *Graphice: The Use of the Pen and Pensil, or the most excellent art of Painting in two parts* (R. Crofts, London, 1658), p. 58.

3 Jerry King, *The Art of Mathematics* (Plenum Press, New York, 1992), pp. 18–23.

4 G. H. Hardy, *A Mathematician's Apology*, with a foreword by C. P. Snow, (Cambridge University Press, Cambridge, 1967, first edition 1940), p. 85.

5 Ibid., p. 89.

NOTES

6 Williams, *In the Azure over the Squalor*, p. 10.

7 William Carlos Williams, "Patterson" in A. Walton Litz and Christopher MacGowan, eds., *Collected Poems of William Carlos Williams*, vol. 1 1909–1939, (New Directions, New York, 1986), p. 262.

8 Williams, *In the Azure over the Squalor*, p. 14.

9 Henri Poincaré, "Mathematical Creation," reprinted in James R. Newman (ed.), *The World of Mathematics* (Simon and Schuster, New York, 1956) vol. IV, pp. 2043–2045. This passage and the ones that follow it in my text are quoted in many other places, for instance it is the first selection in Brewster Ghiselin, ed., *The Creative Process: A Symposium* (University of California Press, Berkeley: 1985) pp. 22–31.

10 Henri Poincaré, "Mathematical Creation".

11 Jacques Hadamard, *The Mathematician's Mind: The Psychology of Invention in the Mathematical Field* (Princeton University Press, Princeton, N. J., 1945; this citation for 1954 Dover reprint of the 1949 edition) p. 48 where he quotes Souriau "Pour inventer, il faut penser à côté."

12 Paul Valéry quoted in Hadamard, op. cit., p. 31.

13 Paul Valéry quoted in Hadamard, op. cit., p. 30.

14 Gary Snyder, "How Poetry Comes to Me," *No Nature: New and Selected Poems* (Pantheon Books, New York, 1993), p. 361.

THE PLOT THICKENS EVERYTHING

This lecture is dedicated to Helen Harvey Mills and was originally delivered on March 8, 2000, in a series of lectures addressing the narrative element in art, organized by Jean Goldman for the Woman's Board of the Art Institute of Chicago.

1 Paul Valéry, "The Centenary of Photography," in Alan Trachtenberg, ed., *Classic Essays on Photography* (Leete's Island Books, New Haven, 1980), p. 192.

2 Ibid., p. 192.

3 Ibid., p. 193.

4 Pierre MacOrlan, quoted in Sarah Greenough, et. al. *On the Art of Fixing a Shadow: One Hundred and Fifty Years of Photography* (Little Brown and Company, Boston, and the National Gallery of Art, Washington, D.C., 1989), p. 239.

5 W. H. Auden, "Musée des Beaux Arts," in *The Collected Poetry of W. H.*

Auden (Random House, New York, 1945), p. 3.

6 Garry Winogrand, *The Man in the Crowd: The Uneasy Streets of Garry Wino-grand* (Fraenkel Gallery, San Francisco, 1999), p. between pls. 10 and 11.

7 Ibid.

IMPERFECTLY UNKNOWN

Adapted from a lecture delivered at the Art Institute of Chicago on June 5, 2001 in conjunction with the exhibition Edward Weston: The Last Years in Carmel (June 2 – October 28, 2001)

1 Robinson Jeffers, "The Old Stonemason" in *Robinson Jeffers: Selected Poems* (Vintage Books, New York, 1965), p. 92.

2 Betty Friedan, *The Fountain of Age* (Simon and Schuster, New York, 1993), p. 69.

3 Harold C. Schonberg, *The Great Pianists* (Simon and Schuster, New York, 1987), p. 174.

4 Alan Walker, *Franz Liszt: The Final Years*, (Cornell University Press, Ithaca, New York, 1988), p. 437–38.

5 Ibid., p. 437.

6 Andrea Bonatta liner notes accompanying Franz Liszt, *Dernières pièces pour piano* (Auvidis-Astrée, 1991)

7 Wallace Stevens, "Puella Parvula" (1950), *The Collected Poems* (Vintage Books, New York, 1990), p. 456.

8 Michelangelo began the *Rondanini Pietà* (Milan, Castello Sforzesco) around 1555, when he was eighty, and left it unfinished. Beethoven wrote his five final quartets in the 1820s; he probably began no. 127 in E flat as early as 1822, when he was fifty-two. He completed the last of the five quartets, no. 135 in F major, during August and September 1826, five months before he died. For a discussion of Beethoven's last quartets as representative of work of the third period of an artist, see Anthony Storr, *Solitude: A Return to the Self* (Free Press, New York, 1988), pp. 170-73.

9 Wallace Stevens, "The Plain Sense of Things" (1954) *The Palm at the End of the Mind: Selected Poems and a Play* (Vintage Books, New York, 1990), p. 382.

10 Dody Thompson, "Edward Weston," *Malahat Review* 14 (Apr. 1970) p. 141; repr. in Newhall and Conger, eds. *Edward Weston Omnibus: A Critical Anthology* (Peregrine Smith, Salt Lake City, 1984), p. 92.

11 Ibid., p. 141.

12 Wallace Stevens, "Credences of Summer," (1947), in *Wallace Stevens: The Collected Poems* (Vintage Books, New York, 1990), p. 376.

13 Wallace Stevens, "The Poem that Took the Shape of a Mountain" (1954), in *Wallace Stevens: The Collected Poems* (New York, 1982), p. 512.

ALFRED STIEGLITZ

Adapted from "Beyond Virtuosity," a lecture for the Phillips Collection, Washington, D.C. (March 16, 1993) and "A Mind Among the Clouds," the Carl J. Weinhardt, Jr. Memorial Lecture delivered at the Indianapolis Museum of Art on 27 March 1997.

1 Alfred Stieglitz, "How I Came to Photograph Clouds," in Nathan Lyons, ed., *Photographers On Photography: A Critical Anthology*, (Prentice-Hall, Englewood Cliffs, New Jersey, 1966), p. 111. The original Stieglitz article was published in *The Amateur Photographer & Photography*, vol. 56, no. 18–19 (1923), p. 255.

2 Ibid., p. 111.

3 Ibid., p. 112.

4 Ibid., p. 112.

5 John Gross, *The Oxford Book of Aphorisms* (Oxford University Press, New York, 1983), p. 297.

6 Dorothy Norman, *Alfred Stieglitz: An American Seer* (Random House, New York, 1973), p. 161.

7 Minor White, "Photography Is an Art," *Design* 49:4 (December 1947), p. 8.

8 We might remark that these three categories (subjective, objective, equivalent) were three successive phases through which Stieglitz's and Weston's careers had passed and from which White was expecting to proceed.

9 Yamanoe Sojiki, quoted in Louise Allison Cort, "Tea in Japan: From the Late 16th Century to the Present," in Hayashiya Seize, *Chanoyu: Japanese Tea Ceremony*, (Japan Society, New York, 1979), 25.

10 Peter Henry Emerson is probably the figure most likely to have been a model for Stieglitz. They were not, however, acquaintances.

11 Rainer Maria Rilke, "Fortschritt" (Moving Forward), from *Selected Poems of Rainer Maria Rilke*, A Translation from the German and Commentary by Robert Bly (Harper & Row, New York, 1981), p. 101.

12 Virginia Woolf, quoted in Wayne Booth, *The Art of Growing Older: Writers on Living and Aging* (Poseidon Press, New York, 1992), p. 21.

13 Ibid., p. 232.

14 Wallace Stevens, "The Plain Sense of Things," from *The Palm at the End of the Mind: Selected Poems and a Play by Wallace Stevens* (Vintage Books, New York: 1990), p. 382.

15 Ibid., p. 332.

16 Dylan Thomas, "Fern Hill," from *The Collected Poems of Dylan Thomas, 1934–1952* (New Directions Books, New York, 1971), p. 178.

17 Walt Whitman, "To Get the Final Lilt of Songs," from *Leaves of Grass, Comprehensive Reader's Edition* (NYU Press, New York, 1965), pp. 521-22.

PAUL STRAND

Adapted from an essay published by in 1993 in Museum Studies *(Vol 19, No. 2) by the Art Institute of Chicago.*

This essay is written in honor of James N. Wood, who appreciated Strand's garden photographs while director of the St. Louis Museum of Art, and who on coming to the Art Institute of Chicago as director in 1980 made it possible to purchase many magnificent Strand photographs for the permanent collection.

Since 1980, the Art Institute of Chicago has acquired thirty-six photographs by Paul Strand. Twelve purchases were made through the Ada Turnbull Hertle Fund. Gifts were received from Helen Harvey Mills, Walter Rosenblum, and the Paul Strand Foundation.

The print of *Fall in Movement* was made by Richard Benson after Strand's death. Before Strand died, Benson had made a master set of the prints in Portfolios Three and Four that Strand approved. These then became the guide prints for the completion of the portfolios.

My appreciation of Strand's work and career has been helped by Walter and Naomi Rosenblum, Michael E. Hoffman, Sarah Greenough, Kaspar M. Fleischmann. I am also grateful for the assistance of Sylvia Wolf, Colin Westerbeck, Anthony Montoya, Catherine Duncan, and Lori Singer in the preparation of the manuscript. – D.T.

1 A group of Strand garden photographs was shown after his death at the Philadelphia Museum of Art in an exhibition organized by Michael E. Hoff-

man entitled *Paul Strand, Discoveries: The Early Years 1915–1916*; and *Garden Images, 1956–1974*," which ran from November 12, 1978 to June 30, 1979. Only recently, November 1992, has an exhibition selected exclusively of Strand's Orgeval garden photographs been presented at the Zabriskie Gallery, Paris. This exhibition was accompanied by an illustrated booklet with an introduction by Catherine Duncan.

2 In 1926, Strand took a vacation to Colorado, where he took at least one natural still life that he included in comprehensive retrospectives of his work.

3 Paul Strand, introduction to Portfolio One, "On My Doorstep" 1976. Also quoted in Kaspar Fleischmann, ed., *Paul Strand*, volume 2, catalogue for the gallery Zur Stockeregg (Zürich, 1990), p. 42.

4 Quoted in Calvin Tomkins, "Profiles: Look to the Things around You," *The New Yorker*, September 16, 1974, p. 44. Reprinted in *Paul Strand: Sixty Years of Photographs* (Aperture, Millerton, New York 1976), pp. 153–5.

5 Strand is described as "remote and austere" in Naomi Rosenblum, *Paul Strand: Orgeval: A Remembrance of Paul Strand* (Lumière Press, New York, 1990), p. 7. His "doggedness and suspension with which he protects himself against conditions" is a character description from a letter from Gaston Lachaise to Alfred Stieglitz quoted in Naomi Rosenblum, *Paul Strand: The Early Years, 1910–1932* (Ph.D. diss. City University of New York, 1978), p. 154.

6 Strand's early street portraits were taken with a lens on which was mounted a right-angle mirror or prism allowing him to photograph ninety degrees from where the camera was pointed. He had tried mounting a fake lens on the body of the Graflex camera, but it was discovered by his subjects.

7 The Orgeval garden is described as "admirably wild" in Basil Davidson, "Working with Strand," in Maren Stange, ed., *Paul Strand: Essays on His Life and Work* (Aperture, Millerton, New York, 1990), p. 217.

8 A full description of the Orgeval garden can be found in Catherine Duncan, "The Years in Orgeval," in Maren Stange, ed., *Paul Strand: Essays on His Life and Work* (Aperture, Millerton, New York: 1990) pp. 231–8, and in Catherine Duncan, "Paul Strand: The Garden, Vines and Leaves" in *Aperture*, number 78, pp. 46-48.

9 Strand's book on France was entitled *La France de Profil* with a text in French by Claude Roy. It was published in Lausanne by La Guilde du Livre in 1952. Strand's book on the village of Luzzara, Italy, was entitled *Un Paese: Portrait of an Italian Village* with a text in Italian by Cesare Zavattini. It was published in Turin by Giulio Einaudi in 1955.

10 The title, *The Apple That Fell, The Garden of Eden* (1973), is written on the verso of an original print in Paul Strand's hand. The other title is written in Hazel Strand's hand. As no other prints with metaphorical titles are in Strand's own hand, one may question whether these titles were his own. It is unlikely that after sixty years of resisting them others would take it upon themselves to assign them without his permission. Catherine Duncan, who worked with the Strands on the garden photographs, remembers that because Paul was not able to write, the titles he created for his last works had to be recorded by Hazel.

11 Another print of *The Great Vine in Death* (1973) bears the title *The Great Vine Alive in Death* and is dated 1972.

12 See Catherine Duncan, "The Years in Orgeval," in Maren Stange, ed., *Paul Strand: Essays on His Life and Work* (Aperture, Millerton, New York, 1990), pp. 236–38.

13 Michael E. Hoffman remembers this to be the working title of Strand book of garden photographs.

14 Catherine Duncan proposes this idea of an open future in "The Years in Orgeval," in Maren Stange, ed., *Paul Strand: Essays on His Life and Work* (Aperture, Millerton, New York, 1990), p. 238.

15 Only one photograph by Paul Strand exists in a mounted and signed "upside-down version." This is his *Mesa Verde*, 1926. This photograph is discussed in Steve Yates, "The Transition Years: New Mexico," Maren Stange, ed., *Paul Strand: Essays on His Life and Work* (Aperture, Millerton, New York, 1990), pp. 90-92.

16 Articles by Richard Benson discussing Strand's printing technique are in "Print Making," Maren Stange, ed., *Paul Strand: Essays on His Life and Work* (Aperture, Millerton, New York, 1990), pp. 103–8 and in Kaspar Fleischmann, "Interview with Richard Benson, Photographer" in Kaspar Fleischmann, *Paul Strand*, volume 2, a catalogue published by the gallery Zur Stockeregg (Zürich, 1987), pp. 136–54.

17 Marius de Zayas, "Photography and Artistic Photography," *Camera Work* 42/43 (April–July 1913), p. 14.

Acknowledgments

I would first like to thank James N. Wood, Director and President of The Art Institute of Chicago for his encouragement of my work as a curator of photography. Several of these lectures and the one essay on Strand were created for the museum or for groups associated with it. The other lectures relate to interests that I was permitted to develop at the museum.

Lecturers often have a few ideal auditors in mind when organizing their thoughts. In my case among them are those who have also been readers for me: Anstiss Krueck, Helen and Ralph Mills, James M. Wells, Colin Westerbeck, Sylvia Wolf, Lori Singer, and my wife, Leslie Travis. To this list I must single out Elizabeth Siegel, who also did extensive line edits of my manuscripts for this book.

My colleagues in the history of photography and art have been particularly helpful in helping to discuss my ideas as they emerged. I am particularly grateful to Tom Bamberger, Sandra Sammataro Phillips, Douglas R. Nickel, John Szarkowski, Gilberte Brassaï, Françoise Heilbrun, Anne Wilkes Tucker, Sarah Greenough, Peter Galassi, Weston Naef, Maria Morris Hambourg, Richard Brettell, Marie-Thérèse and André Jammes, Jean-François Chevrier, Alain Sayag, Susan Ehrens, Michael Simon, Charis Wilson, Amy Conger, William A. Turnage, Walter and Naomi Rosenblum, Elizabeth Hutton Turner, Jean Goldman, and the late Philippe Neagu, Michael E. Hoffman, and Romeo Martinez. Photographers and artists, too, have been essential to the maturation of certain ideas and I must thank Henri Cartier-Bresson, Martine Franck, Danny Lyon, Stuart Klipper, Irene Siegel, Terry Evans, Leland Rice, Joel Sternfeld,

Lee Friedlander, Cole Weston, Pirkle Jones, Doty Warren Thompson, Tom Arndt, and those who have passed away: Brassaï, André Kertész, Michel Seuphor, Ruth Marion Baruch, and Rose Mandel. A few scientists and mathematicians, who have kept me from going astray in those more exacting fields of study, deserve special mention: Robert F. Coleman, William Wimsatt, Robert Hazelkorn, and my father-in-law Bernard S. Strauss.

Without these following museums and schools none of the lectures would have been either fully developed or presented: The J. Paul Getty Museum, the Rochester Institute of Technology, the Indianapolis Museum of Art, the Phillips Collection, the Arts Club of Chicago, the Museum of Modern Art, the Metropolitan Museum of Art, and, of course, The Art Institute of Chicago.

I am also grateful to David R. Godine for our long friendship and our shared passions for calligraphy, typography, sailing, nautical history, and photography. He was one of the first in my career to demonstrate that books of intelligence and beauty can still find their way into print. Over many years, I have learned and profited from the excellent editorial counsel of Susan F. Rossen and Robert V. Sharp. I am grateful to Carl W. Scarbrough for his excellent design and coordination of this book, as well as to my assistant Lisa D'Acquisto for her untiring efforts to see that all things went smoothly as the book was assembled. No acknowledgement of anything in my career and thinking would be complete without mention of my mentor Hugh Edwards, now long departed but never forgotten.

All photographs by Brassaï (frontispiece and 21) © Gilberte Brassaï; 21 courtesy of Nicholas Pritzker; 2 © Alice Springs. All photographs by André Kertész (34, 36, 37, 38, 40, 43, 46, 49) © Estate of André Kertész and courtesy of the Art Institute of Chicago; 36 courtesy of the New Orleans Museum of Art; 58 and 71 © The Lane Collection, courtesy, Museum of Fine Arts, Boston; 61 © Henri Cartier-Bresson; 64 and 92 © Estate of Garry Winogrand; 66 © 2003 Robert Cumming and courtesy Janet Borden Gallery; 69 © 2003 the Trustees of Princeton University and courtesy the Minor White Archive, Princeton University Art Museum; 80 and 85 © Joel Sternfeld; 93 © W. Eugene Smith / Black Star. All photographs by Edward Weston (96, 98, 99, 100, 101, 102, 103, 104, 105, 106, 117) © the Regents of the University of Arizona Tucson; 96, 98, 99, 100, 101, 102, 104, 117 courtesy of the Art Institute of Chicago; 103 © The Lane Collection, courtesy, Museum of Fine Arts, Boston; 107 © Estate of Clyfford Still and courtesy of the Art Institute of Chicago. Photographs by Alfred Stieglitz (120, 125, 128, 129, 131, 132, 133, 134, 138, 141, 142, 143, 144) courtesy of the Art Institute of Chicago; 139 © 2003 The Georgia O'Keeffe Foundation / Artist Rights Society, New York and courtesy of the Museum of Modern Art; 145 © 2003 Board of Trustees, National Gallery of Art, Washington, D.C. All photographs by Paul Strand (146, 148, 149, 150, 152, 157) © Paul Strand Archive, Aperture Foundation; 157 courtesy of Walter Rosenblum.

At the Edge of the Light has been set in a digital version of Monotype Bembo, a type modeled after the faces cut by Francesco Griffo for the great Venetian scholar-printer Aldus Manutius, and first used in 1495 for Aldus's edition of *De Aetna* by Pietro Bembo, then secretary to Pope Leo X. Throughout its history, the Bembo type has been closely associated, usually to disadvantage, with Griffo's other Aldine types, most particularly that used for Francesco Colonna's *Hypnerotomachia Poliphili*. In the modern era, the type was routinely denigrated by influential admirers of Nicolas Jenson's types – most notably William Morris and Daniel Berkeley Updike – but even their opinions could not prevent Bembo from becoming one of the most popular and recognizable types for book work. ℂ When Bembo was being cut for Monotype composition, under the direction of Stanley Morison, an attempt was made to adapt a chancery italic drawn by the esteemed calligrapher Alfred Fairbank as a complement to the roman. The resulting type, elegant when used alone on the page, fared poorly in combination with the broader and more robust roman, and was ultimately released as a separate type. In the end, Bembo was allied with an italic based primarily on the hand of the Renaissance writing master Giovannantonio Tagliente. Morison's own comment on the finished type – admittedly something of a compromise – was, "While not disagreeable, it is insipid." This assessment, perhaps unduly harsh, downplays the italic's comfortable harmony with the popular and very useful roman.

Design and composition by Carl W. Scarbrough